IMAGES of America
SEBASTOPOL

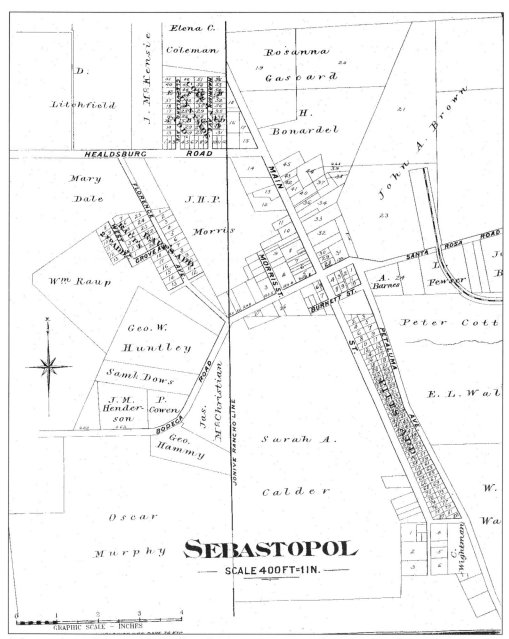

Sebastopol is still surrounded by farm land as it begins to subdivide around 1905.

IMAGES of America
SEBASTOPOL

The Western Sonoma County Historical Society

Copyright © 2003 by The Western Sonoma County Historical Society.
ISBN 0-7385-2852-8

Published by Arcadia Publishing,
an imprint of Tempus Publishing, Inc.
Charleston SC, Chicago, Portsmouth NH,
San Francisco

Printed in Great Britain.

Library of Congress Catalog Card Number: 2003109044

For all general information contact Arcadia Publishing at:
Telephone 843-853-2070
Fax 843-853-0044
E-Mail sales@arcadiapublishing.com
For customer service and orders:
Toll-Free 1-888-313-2665

Visit us on the internet at http://www.arcadiapublishing.com

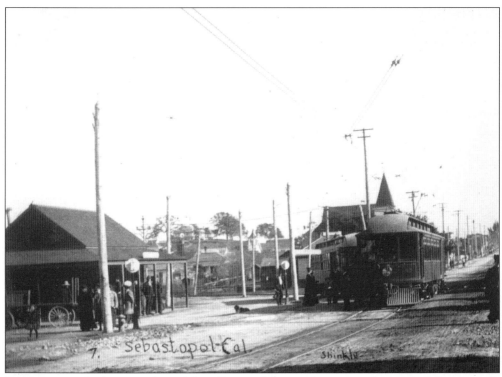

Passengers catch the train down Main Street while people wait at the original Petaluma & Santa Rosa railway depot on the left.

Contents

Acknowledgments		6
Introduction		7
1.	Along the Laguna de Santa Rosa	9
2.	When the Railroads Came to Town	15
3.	Meanwhile Back at the Ranch	21
4.	Luther Burbank in Sebastopol	35
5.	Our Diverse Community	43
6.	More Hither than Yon	59
7.	Slates and Prayer Books	73
8.	In Our Spare Time	87
9.	Getting Down to Business	101

Acknowledgments

We wish to thank the following without whose help this book would not have been possible.

Research and Text: Margaret Marshall, Evelyn McClure, Sally Morrison Giberti, Rae Swanson, and Western Sonoma County Historical Society Archives staff members Claire Clarke, Will Roberts, Betty Short, and Rae Swanson.

Photographs were provided from the collections of the people or organizations listed below. In most cases an abbreviation follows the contributor's name; these are used throughout the book to denote those images.

Tom and Donna Barlow (B)
William Borba, Ron Chamberlain, Bunni Cogsdell, Dick Hogan, Harold Narron, Bud Daveiro, Stanley Strout, Gary Crowe and Robert Crowe Family, and Edward Trigeiro, WSCHS Archives.
Gene Buvelot (GB)
Tom Vano, San Francisco, Vano-Wells-Fagliano, courtesy of the Charles M. Schulz Museum and Research Center (SMRC)
John Colombo (JC)
Enmanji Temple staff (ET)
Shizue Hamaoka (SH)
Japanese American Citizens League Library (JACL)
Luther Burbank Home & Gardens (LBHG)
George Kikuchi (LK)
Mrs. Don McDonell (DM)
Margarette Murakami (MM)
Leo Nauman (LN)
Edith Norton (EN)
Gloria and Don Roberts (GDR)
Sebastopol Fire Department (SFD)
Sebastopol Police Department (SPD)
Sonoma County Library, History and Genealogy Library (SCL)
Sonoma County Museum (SCM)
University of California Los Angeles Library Archives (UCLA)
Western Sonoma County Historical Society Archives (WSCHS)
Wanda and Marvin Zimpher (Z)

INTRODUCTION

In 1855, six years after the beginning of the Gold Rush in California, Ohio emigrant Joseph Morris claimed government land between two Mexican land grants and started the town of Pine Grove. Some time after this a Mr. Stevens and Mr. Hibbs had words, escalating into a fight, leading Mr. Stevens to take refuge in the general store. The storekeeper would not let the fight continue on his premises so Mr. Hibbs waited all day for Mr. Stevens to exit. People said this was Mr. Hibbs "Sebastopol Standoff," just like in the Crimean War that was being fought overseas at that time.

Later, when a post office was to be opened for the town, there already was a Pine Grove in California so the townspeople chose Sebastopol as the new town name. Thus began the quirky history of Sebastopol that some say continues today. To illustrate that point, we are a designated "nuclear free zone."

From the 1850s, immigrants have arrived here after learning what great potential this land has for farming. Early on, people grew fruit of all kinds, especially grapes and apples. Great wealth was built from hops grown before Prohibition, and the apple industry hit its peak around World War II. Grapes were grown since the turn of the century and are now making a resurgence, along with a great deal of interest in organic farming.

The Western Sonoma Historical Society's archives and photographs gathered from private collections provide a look into many areas of local history in our city. The variety of life here is impressive. In the 1920s, for example, we had an established airport where pilots provided thrilling barnstorming rides. And before that, in 1903, the Petaluma and Santa Rosa electric railroad established Sebastopol as the crossroads to stations north, east, and south (the 1917 P&SR Depot now provides a home to the West County Museum). Luther Burbank, who lived in Santa Rosa, purchased 18 acres in Sebastopol in 1885 to expand his legendary botanical experimentation; 3 acres of his original farm have been preserved by the historical society. The museum and farm, as well as one home from 1903, are on the National Register of Historic Places.

Sebastopol boasts many distinct architectural styles of homes still preserved in their original state. Meanwhile, the former Odd Fellows and Masonic cemetery contains the burials of many people significant to the history of California, including members of the Donner Party, the Bear Flag revolt of 1846, Luther Burbank's sister and mother, and many pioneers of the West County.

As for natural surroundings, the Laguna de Santa Rosa—one of Sonoma County's most significant watersheds—flows through Sebastopol. In the 1920s, this scenic body of water was used for recreational bathing; today it provides a home for many species of flora and fauna.

Sebastopol's diverse ethnic history is embodied in such structures as the Enmanji Temple, now home to a Buddhist congregation. This amazing building was brought here from the 1933 Chicago World's Fair and reconstructed without nails. Portuguese from the Azores Islands, Japanese farmers via Hawaii, Native Americans, and others also add to our cosmopolitan makeup.

The Western Sonoma County Historical Society works to inform the public about local history as well as preserve it. Through this collection of photographs, we hope you will enjoy this look into Sebastopol's past.

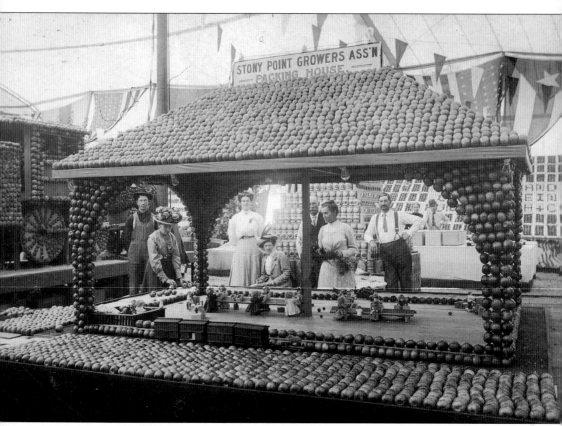
Sebastopol's first Apple Show in 1910 gave individual farmers and cooperatives the opportunity to promote their products.

One
ALONG THE LAGUNA DE SANTA ROSA

Ten thousand years ago, Native Americans inhabited the Laguna de Santa Rosa, and to date, 11 Pomo village sites have been identified on the Laguna. The Mexican era began when Joaquin Carrillo petitioned for ownership of the Llano de Santa Rosa Rancho in 1844, and within Carrillo's resulting land grant was the Laguna. John Walker and James Miller, two men who were among the white settlers arriving beginning in 1850, operated a trading post along the Laguna two miles south of present-day Sebastopol. With the arrival of more settlers and the beginning of the farming industry, trees were removed from the Laguna, sediment gradually created dams, and three lakes were formed: Lake Jonive, Cunningham, and Ballard. On Lake Jonive, north of Analy High School, people boated, swam, sunned, and fished in the early 1900s. In 1915, property owners along the Laguna wanted to form a drainage district and drain the Laguna to increase the value of their land. In the 1930s, the Civil Conservation Corps employed young men to make ditches and dams to control drainage into the Laguna.

Sebastopol's main purpose when the city incorporated in 1902 was to take care of sewage problems. To accomplish this, the city obtained free land along the Laguna de Santa Rosa from John A. Brown to locate a sewer farm. Workers cleaned up town cesspools and septic tanks, but the effluent ended up in the Laguna. Lake Jonive was showing signs of contamination from untreated waste by 1906.

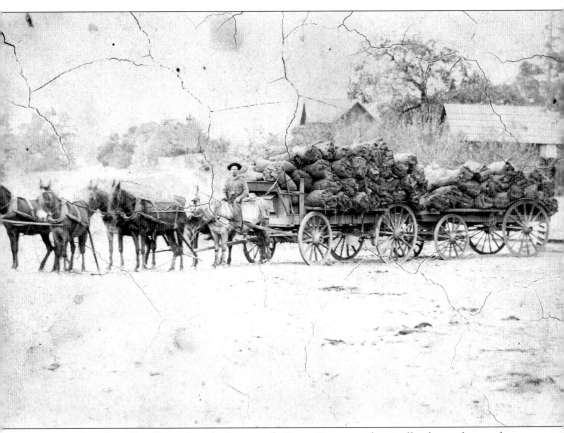

Historian John Crevelli tells us that the Laguna de Santa Rosa was drastically changed as settlers cleared land for planting or burned wood to produce charcoal. In 1859, writer Bayard Taylor visited the county and observed the "fields of blackened and girdled skeletons . . . hideous in contrast" to survivors. In 1878, 150 carloads of charcoal were shipped by rail from Fulton, north of Sebastopol.

On Sebastopol's eastern edge, John A. and Barbara Ellen arrived from New York state in 1861 to make their home (below right, still standing and used today as a veterinarian's office) in the late 1800s. John Brown bought 1,400 acres of land along the Laguna de Santa Rosa, most of which he leased to other farmers. In the background (above) is the open field that became Cnopius Field in the 1920s, used by local flight enthusiasts and visiting barnstormers. A nearby street is named for the Browns. (Courtesy of Sonoma County Museum.)

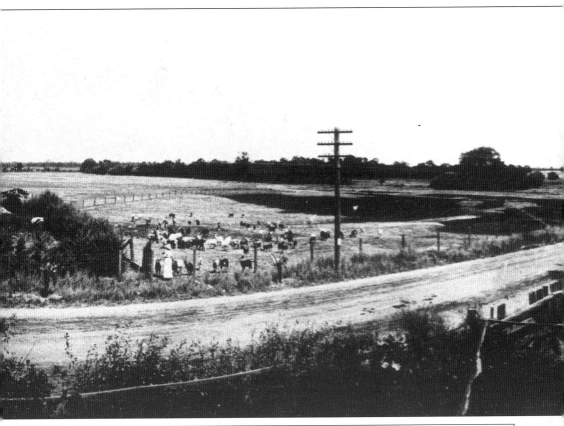

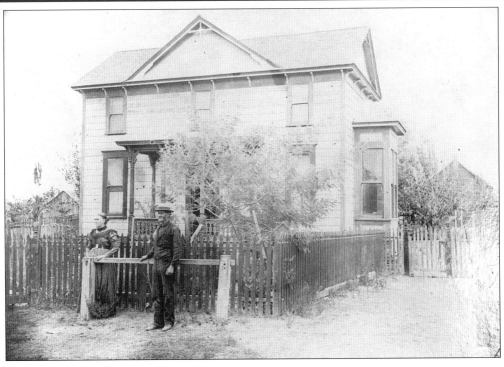

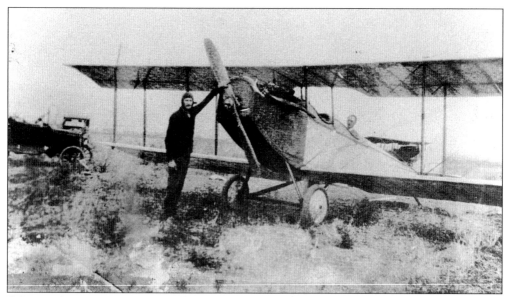

Sebastopol's airport, Cnopius Field, was established in the 1920s. Sam Huck Sr. (pictured here), Fitzgerald, Jim Ford, and the Guglielmetti brothers graded the field to make a runway. Sam Huck joined the Signal Corps, learned to fly during World War I, and after the war gathered together several surplus Jenny airplanes. Like other barnstormers, Sam flew to nearby airfields and offered rides for a standard fee of $10—good money in Depression times.

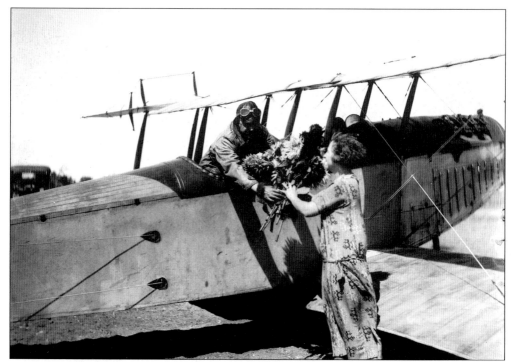

Tee McMenamin Rose brings a bouquet to barnstormers at the Sebastopol airport in 1930. Mrs. Rose was more known for her writing than flying, however. In 1947, she won a new Ford auto for writing a romance play about early California that was broadcast on the Mutual Network.

Two
WHEN THE RAILROADS CAME TO TOWN

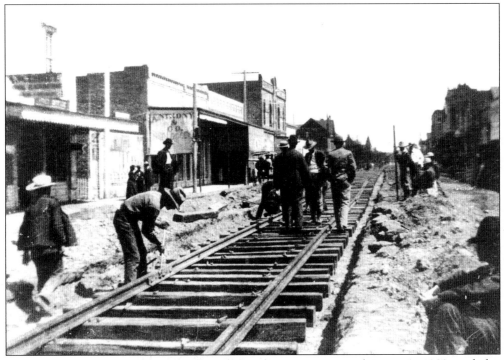

The Petaluma and Santa Rosa Railway (P&SR) was incorporated June 20, 1903, and this marvelous new electric rail system proved to be a boost to Sebastopol's fruit industry and made famous the Gold Ridge region and the Gravenstein apple. The railroad's first spike was driven at Petaluma in April of 1904, and by October the first passenger car reached Sebastopol. In the years that followed the train hauled passengers and freight, while fruit, eggs, milk, and lumber were shipped out to docks in Petaluma and on to San Francisco, and poultry feed, cattle feed and oil for fruit dryers were shipped into the county. Passenger cars carried businessmen and merchants to work, children to school, and young adults to college in Santa Rosa.

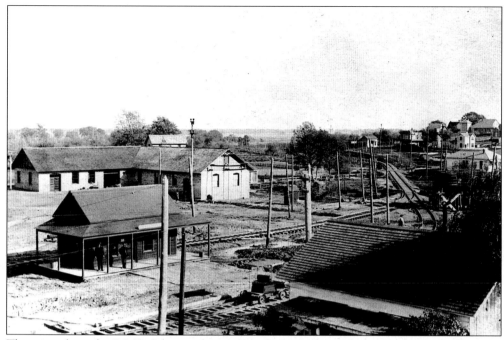

The original wooden P&SR Sebastopol station was built in 1904 with the stone powerhouse in the rear. Before 1903, public transportation in Sonoma County was challenging at best, even though horse-drawn streetcars provided basic public transport. The county's many dirt roads, however, were sometimes impassable in winter and spring and were choked with dust in the summertime.

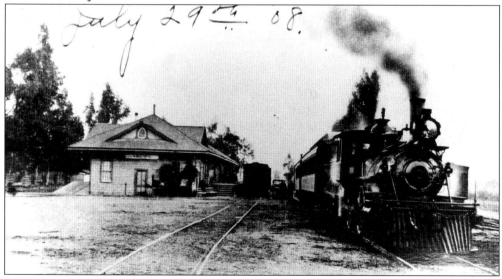

This photograph shows the Northwest Pacific Railroad's Sebastopol Depot as it looked in 1908. At the beginning of the 20th century, Sonoma County was served by the California Northwestern Railroad—later the Northwestern Pacific Railroad—with branch service to Sebastopol via Santa Rosa.

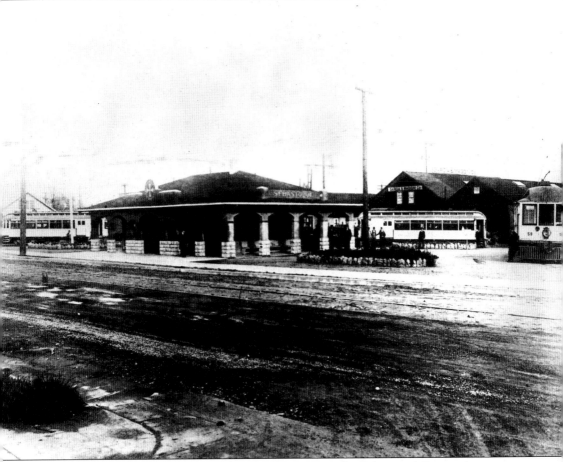

Simultaneous train departures offer a sight not often seen at the Sebastopol Depot: the car at the far left is leaving for Forestville, while the center car is headed for Santa Rosa and the car at the right is leaving for Petaluma. Sebastopol's original wooden depot station, built in 1904, was replaced 13 years later in 1917 with a larger stucco and stone building. Prominent Petaluma architect Brainerd Jones designed the new passenger station which included a ten-foot-wide covered passage that encircled the building and stone piers built with rock from the Stony Point Quarry. Also made from Stony Point rock is the stone powerhouse that served as the freight depot and housed the step-down transformers for the Sebastopol substation. In 1996 the P&SR Sebastopol Depot was placed on the National Register of Historic Places and it is still in use today as the home of the West County Museum.

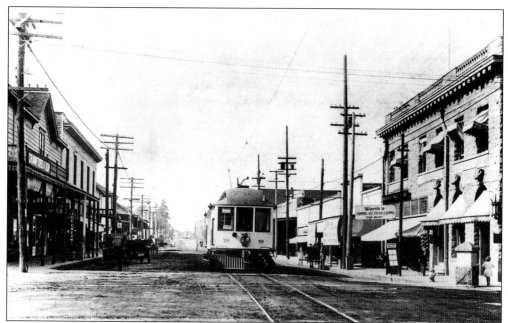

The "Train Down Main," as it was called in its day, made its first trip up Main Street in 1904. It was not loaded with passengers, however, but with cement and crushed rock headed for the construction site of the new powerhouse. The locomotive used at the time wasn't electric but steam—this arrangement was used until construction was completed on the overhead electric lines.

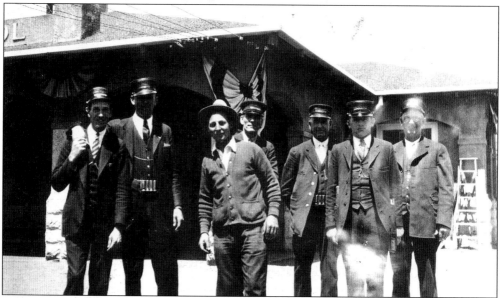

In addition to hauling produce and people, the P&SR brought non-agricultural employment to the area, as evidenced by the 47 miles of tracks the railroad company had installed from Petaluma though Sebastopol and onto Santa Rosa in the main line by 1926. Branch lines were also installed to Forestville and Two Rock, with stations located about a mile apart throughout the system. Passenger stops, however, were more frequent and consisted of shelter sheds and wood-frame platforms.

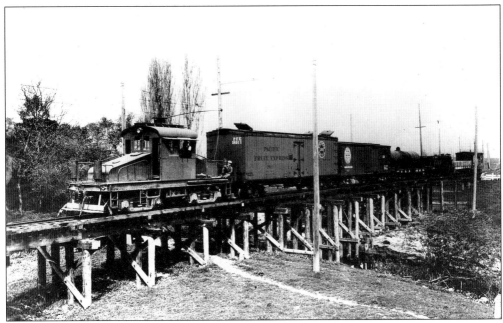

This P&SR freight train pulling Pacific Fruit Express cars is headed by motor 502 near Petaluma. The overnight freight service to San Francisco was critical in the making of the local fruit industry. Express service meant farmers could have their fruit loaded at any point on the rail line anytime during the day until late afternoon, and it would be on breakfast tables in San Francisco the next morning.

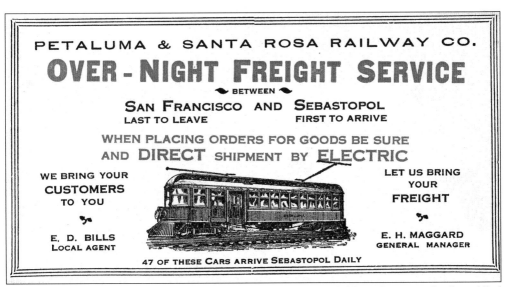

This P&SR advertisement publicized the overnight service available to farmers. The fruit-filled freight cars were unloaded at the wharf in Petaluma and then loaded on to one of two steamer boats that traveled down the Petaluma River and across the bay to San Francisco. The overnight service also benefited merchants in towns along the rail line by allowing them to replenish stock on their shelves within one day.

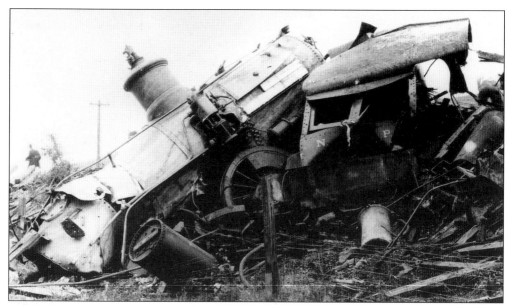

Train wrecks were an unfortunate but familiar sight during the railroad years, as shown in this wreck of Engine #20 that occurred in 1910.

The decline of the P&SR began in the 1920s with the advent of the automobile and the free-form mobility it brought with it. The passenger service was the first casualty, and passenger traffic had disappeared by the early 1930s. During the Depression years railroads suffered, and the general business failures and massive unemployment in the larger economy all aided in the railroad's decline. This is one of the few remaining cars from the P&SR; it has been turned into a private residence.

Three
MEANWHILE BACK AT THE RANCH

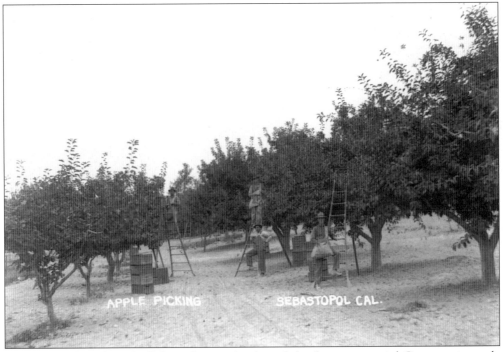

In 1890, Nathaniel A. Griffith inadvertently planted the first commercial Gravenstein apple orchard at Vine Hill. Griffith and botanist Luther Burbank later identified those trees as the Gravenstein, an apple originally developed in Germany. Griffith's success with the Gravenstein led other farmers to plant them, and by the 1940s more than 9,000 acres were planted in Gravensteins around Sebastopol. Some of the sheer apple tonnage was impressive, such as the 112 tons of fresh apples handled daily in season by O.A. Hallberg and Son's plant in Graton, the largest in the West. There were 14 other apple processors (individuals and cooperatives) operating in the area along with 80 dehydrators. Speas in Sebastopol made apple brandy, while the Barlow family produced commercial vinegar, applesauce, canned apple slices, and apple butter at the Barlow Company in Sebastopol and at the Occidental Road cannery. Sebastopol continues to celebrate the apple at the Apple Blossom Festival and the Gravenstein Fair each year. However, to give that other major agricultural product its due, grapes have always been with us as well. And even though 1936 was a peak apple production year, more grapes than apples were grown in that year, and today grape planting far exceeds apple acreage.

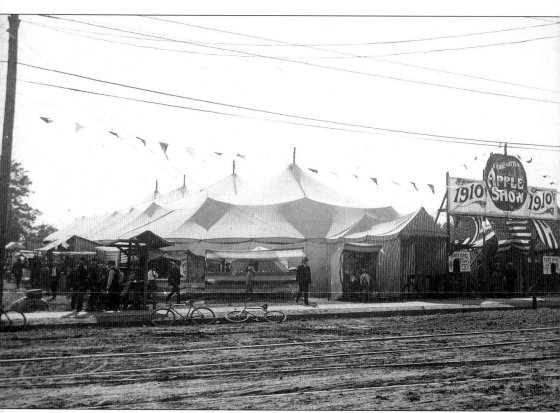

The Sebastopol Apple Show, held in a tent across from the P&SR Depot in August 1910, promoted local fruit in various creative ways. Festivities were disbanded in 1917 but resurrected in 1928 by the American Legion, although World War II later cooled interest. The Farm Trails Association revived the idea in 1973 by holding a fair at the Enmanji Temple, and the Gravenstein Fair moved to Ragle Park in 1977.

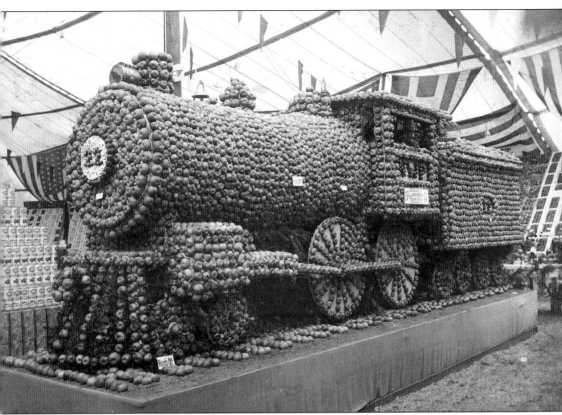

Frank Huntley and James Morris deservedly won first prize for this apple-covered locomotive at the 1910 Apple Show. Occasional surplus crop years, such as 1949, further challenged marketing efforts, resulting in San Francisco restaurants featuring apple-heavy menus. Farmers hoped to sell one million boxes of fresh fruit that year of their four million-box production. One box of apples sold for $1.90.

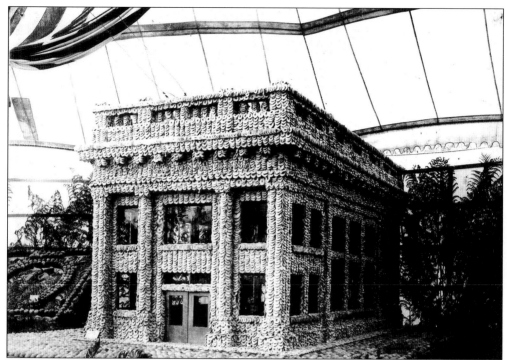

Apple growers chose fanciful things to portray in their apple displays, as this 1915 photograph demonstrates. That year, the Apple Show was brought to the Panama Pacific Exposition in San Francisco for the Sebastopol Apple Day. At this event, Luther Burbank waved a wand over a super-size Gravenstein and out stepped Elva Howell, queen of Gravenstein Apple Day.

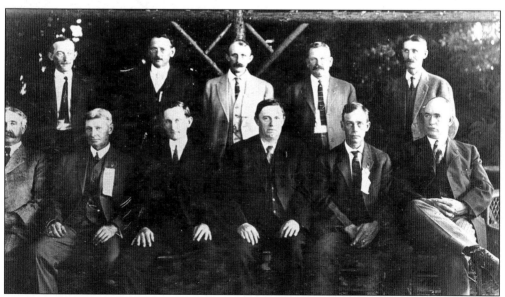

The 1913 Apple Show organizers included, from left to right, (front row) unknown, George Sandborn (local realtor), Louis Howell (local merchant), unknown, Henry Elphick, and Jim Kelly (fruit broker and Sebastopol's mayor 1910–1912); (back row) A.B. Swain (local banker), Al Garcia (Garcia & Maggini), A.J. Peterson, Charles Hotle (a local grower), and Mr. Harbine.

Apple Blossom queens were chosen from local high school contestants. In 1968 Charles M. Schulz, creator of the *Peanuts* comic strip, led the parade as grand marshall. Out-of-season apple pie, folk dancing and vintage machinery awaited the festival's 15,000 visitors that year. (SCL)

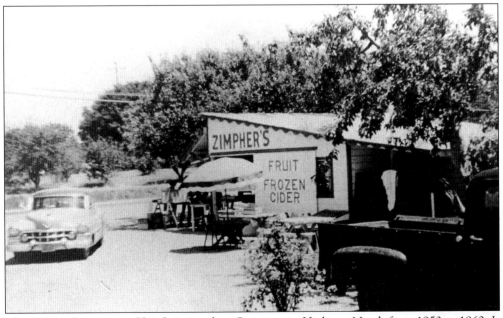

Marvin Zimpher operated his fruit stand on Gravenstein Highway North from 1953 to 1962. It was located on the north end of today's Redwood Marketplace. They sold local produce and fruit from the Sacramento Valley, since by that time Sebastopol-area farms were no longer growing peaches and cherries. The fruit stand stood on property adjoining Donald Zimpher's chicken ranch. Marvin and his father, Donald, subdivided the property in the 1960s, starting their construction business. (Z)

John F. Hallberg came to Sonoma County from Sweden in 1880. He built an apple dryer in 1897, which unfortunately burned in 1905, so his sons Oscar and Alfred built another in 1916. Oscar became a farming impresario of sorts, buying apple orchards until he had 500 acres. In 1939 he started to can applesauce and bought the Green Valley Cannery in Graton. (B)

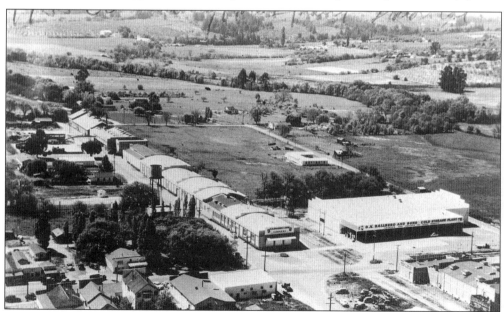

The Hallberg plant in Graton, located in a former winery, installed power fruit dryers in 1919 and in that year the company processed 100 tons of apples. To dry one ton of apples, 175 gallons of oil were needed. Apples were machine-peeled, sulfured, and then dried for 12 hours. In 1919, the plant's 15 employees turned out $40,000 worth of dried apples. (B)

Realtor George Keefe originated the Apple Blossom Tour in 1947. Alfred Hallberg, pictured here, worked with local Boy Scouts to post some 60 signs to guide visitors. It was estimated that 4,000 visitors took the Blossom Tour that year, and the figure is believable, as the Boy Scouts counted 352 cars in 4 hours on the route during one weekend.

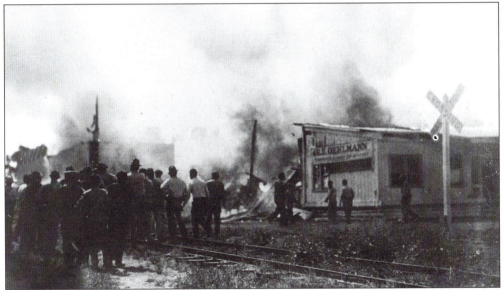

Remnants of early 20th-century apple dryers dot the Sebastopol area, many of them originating from Japanese farmers. Until the internment camps began in 1942, Japanese families operated 72 dehydrators. Consolidation resulted in 30 larger plants that were operated individually or as cooperatives. While dryers expedited the processing, fire was an extreme hazard in fruit drying. This fire occurred in 1948 at the R.E. Oehlmann Evaporator/Manzana Products, which was rebuilt as an apple cannery after the fire. (EN)

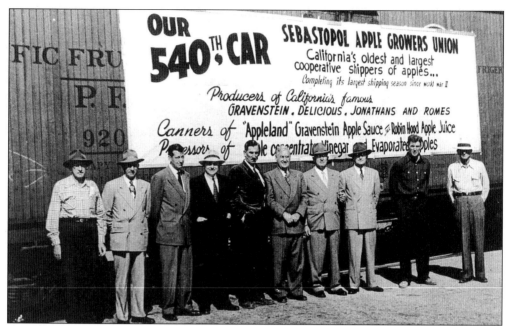

The Sebastopol Apple Growers Union ships its 540th rail car of Appleland and Robin Hood brands. In the 1930s, 50 cars from all growers were shipped daily. Pictured, from left to right, are B.C. Berry, Ivan Roberts, Paul Yowell, Frank O. Linehan, Rollo W. Winkler, David M. Durst, H.S. Graham (traffic manager, P&SR Railroad), H.L. Hotle (president, Bank of Sonoma County), E.W. Arnold, and Fred Miller.

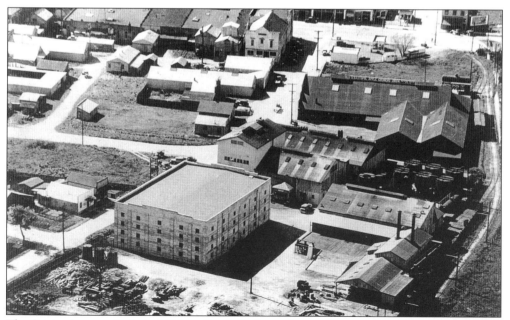

The Speas plant was built in 1919 by Frank Butler and was subsequently sold to Speas in 1929. The company, which made and stored vinegar and distilled apple brandy, was later sold to the Pillsbury Company in 1968. The plant stood empty for many years until new owner Guy Duryee and architect Vernon Avila converted the building into the Sebastopol Cinemas in 1993. (GDR)

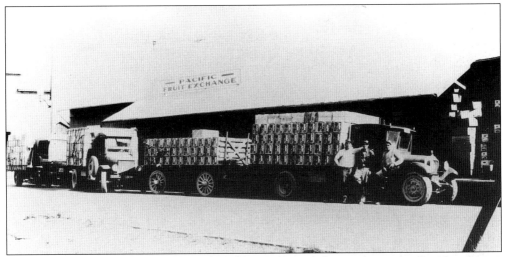

Before a blight discouraged the growing of cherries in the Sebastopol area, local packinghouses processed 1,200 tons of the fruit in 1942. Cherry processors included the Sebastopol Cherry Growers Association, The C.P.C., and the Pacific Fruit Exchange. (SCL)

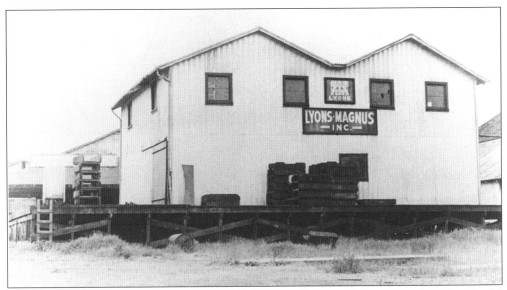

Through 1968, Juanita Borbeau had managed the Lyons-Magnus cherry processing plant for 16 years, during which time the plant processed 540 tons of Royal Anne and Bing cherries. The cherries spent six weeks immersed in chemical brine until they were colorless and tasteless, whereupon Lyons-Magnus's San Francisco plant added taste and color back to make maraschino sundae toppers. Mrs. Borbeau repaired all the plant's machinery, did paperwork, and supervised employees. Workers were kept cold-virus-free thanks to the plant's acid environment. (B)

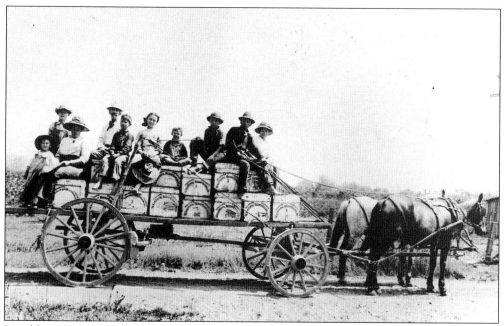

Local berry growers formed the Sebastopol Berry Growers Association in 1909 to help growers obtain the best prices for their product. By the 1920s, 360 farmers grew berries around Sebastopol, with blackberries and loganberries being the principal berries grown. In 1918, some 3,200 tons of berries were canned or shipped from this area. (B)

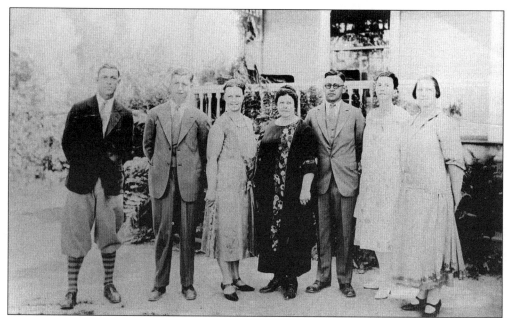

In 1892, Thomas E. Barlow and his wife, Laura, planted 100 acres of blackberries between apple tree seedlings. Others did the same and soon 4,000 acres of berries were bearing fruit. The Barlows invited hundreds of children from the Children's Aid Society to camp out, pick berries, and earn some spending money. The Barlow family, from left to right, are W.J. (Bill), Denman, Maude, Laura, Leland, Louise, and Bess. (B)

The Barlow Ranch is pictured here in 1906 with berry picker's tents visible under the trees. The P&SR Railroad stopped at Barlow Station at the ranch, where Leland Barlow built a cold storage plant to pre-cool apples before packing, a new technique at the time. (B)

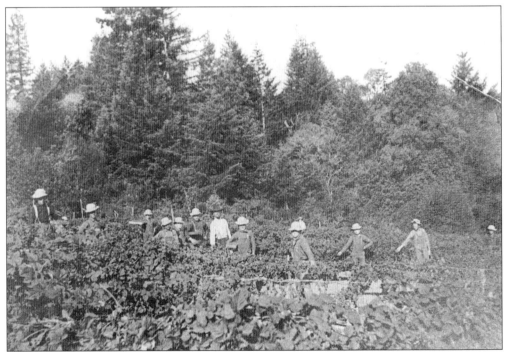

With so many berries, the boys and girls of the Children's Aid Society had plenty to eat and pick. In 1919, each young picker earned a share of the $10,000 in wages paid. Mrs. Barlow's berry patch produced two to three tons of berries per acre each year with no fertilizer needed. The Barlow's apple orchards, on the other hand, absorbed 150 tons of chicken manure, probably produced locally. (B)

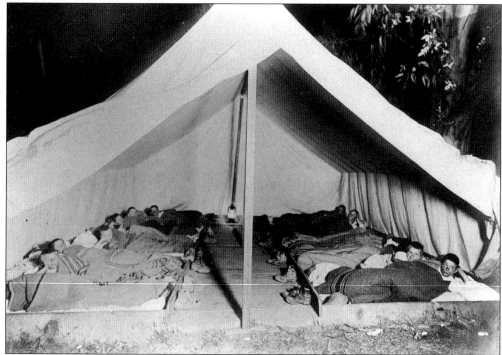

The children who picked berries in the Barlow and other's berry fields were provided with a well-balanced day, with some work but play time as well. On Sundays they went to church, and in their other spare time they played sports and made music. Their day ended with the playing of "Taps" and the lowering of the American flag. (B)

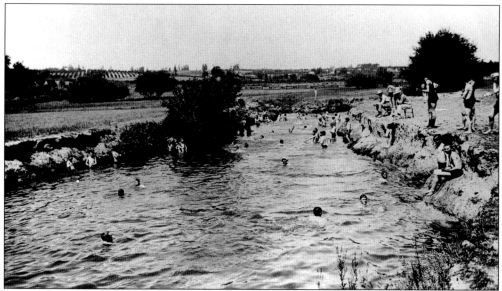

Part of the berry picker's recreation was a visit to the local swimming hole; this one was at Miller's Dairy on Mill Station Road. The children were also taken to the Apple Show in Sebastopol where they viewed apple sculpture, musical performances, and apple pie contests. They probably had their fill of apples and berries by the time they returned to the city. (B)

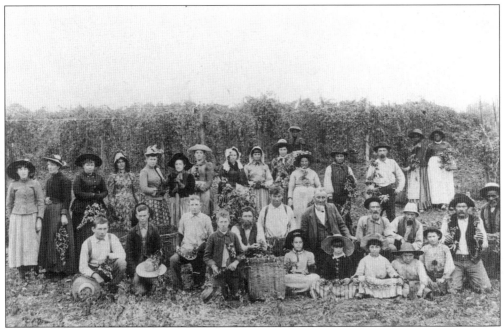

Pickers at the Thomas Miller hop ranch in the Hall District can be seen in this 1880 photograph. Amasa Bushnell brought the first hops to Sonoma County in 1858, planting them on his Green Valley ranch. Other growers such as Samuel Talmadge, Otis Allen, the Purringtons, and the Petersons followed suit by growing hops along the Laguna de Santa Rosa. Fortunes were made in hops before a mold appeared in 1903, presaging their demise. (B)

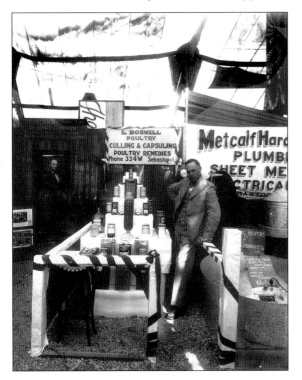

Lawrence Boswell processed chickens and, accordingly, sold chicken pharmaceuticals at his business, which was located near today's Pellini's Chevrolet agency and yesterday's Chinatown. This display at an Apple Show lists capsuling as one of his services; somehow he could get a chicken to swallow its medicine. Many poultry growers brought their chickens to be prepared for market, which Mr. Boswell did, then shipped via ferry from Petaluma to San Francisco.

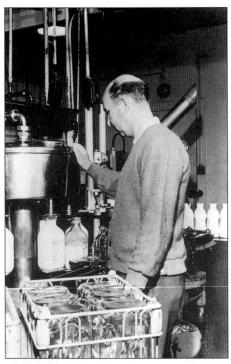

Don Meacham is shown bottling milk at Miller's Dairy in this 1970 photograph. The dairy started in 1930 with 20 Ayrshire cows in the care of Leslie and Marjorie Miller. Bear Flagger Patrick McChristian's cabin, built in 1848, still stood on the Miller ranch at the time. Milk sold for as low as 16¢ a gallon during the Depression. In the 1970s, the Millers sold their milk routes along with half their herd and only produced raw milk for health food stores. (SCL)

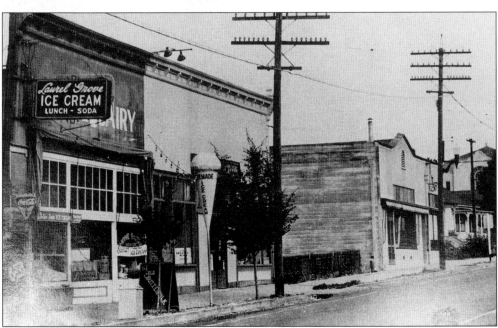

The plain along the Laguna de Santa Rosa was a natural place for dairy farmers such as Robert Cunningham, whose farm had 1,200 acres, 125 cows, and a creamery. Others offering milk products included the Ungewitters at Green Valley Dairy, the Bodega Cooperative Creamery, and Anton Rust at the California Cheese Company. Knowles, LaFranchi, Volkerts, Farrell, Robinson, Slattery, Bonetti, Gambini, Piezzi, Doyle, Pozzi, and Edgerton were other familiar names known in our dairy land.

Four
LUTHER BURBANK IN SEBASTOPOL

Luther Burbank, self-educated horticulturist and prolific plant breeder, was one of the world's most famous men of his time. As a young man, the Massachusetts-born Burbank came west to California in 1875 looking for the perfect climate for his horticultural experiments and found his "chosen spot" in Sonoma County. Settling in Santa Rosa, he purchased 18 acres of land in Sebastopol in 1885, and for the next 41 years he propagated and hybridized plants at his Gold Ridge Experiment Farm. During his illustrious career he developed over 800 new plants including his famed Santa Rosa plum and the Shasta Daisy.

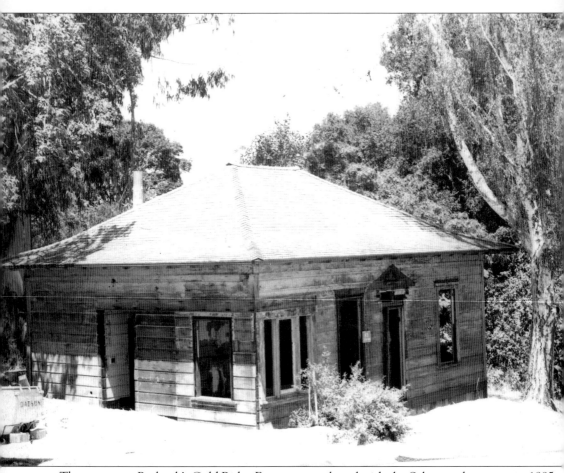

The cottage at Burbank's Gold Ridge Farm was purchased with the Sebastopol property in 1885 and was used as an office and workshop where the botanist kept detailed records of his extensive plant experiments. It also served as his sleeping quarters where he slept two to three nights every week, working from early morning until dark. The cottage was destroyed in the 1906 earthquake, but the irrepressible Burbank rebuilt it in the following year.

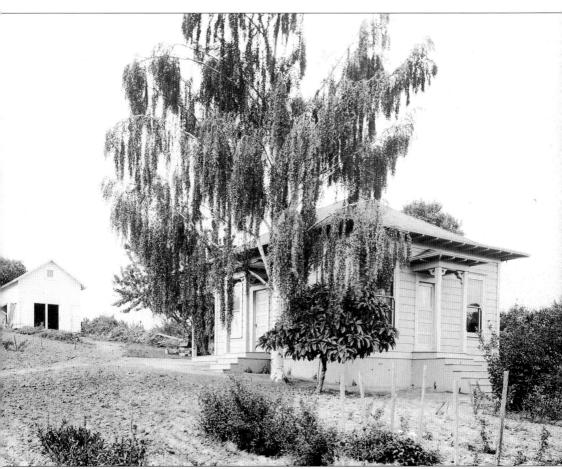

By the 1980s the Gold Ridge Farm cottage was in complete disrepair with only three acres remaining in Burbank's original 18-acre farm. Saved by the diligence and hard work of a small group of volunteers from the Western Sonoma County Historical Society Farm Committee, Burbank's cottage was lovingly restored and preserved for future generations of gardeners. Over 200 of Burbank's original plantings still thrive at Gold Ridge Farm.

For over 40 years Burbank experimented with plant breeding, hybridization, and selection at his farm, and his work was accomplished on a phenomenal number of plants. At any one time he had as many as 3,000 experiments in process, involving millions of plants. In his crossbreeding work with plums, for example, he tested almost 30,000 new varieties.

Burbank planted this Royal Black Walnut hybrid (left) at Gold Ridge Farm in 1885. A northern California and Eastern species hybrid, this walnut tree produced almost 2,000 pounds of walnuts a year and is the heaviest nut producer of any kind of tree developed. From 1887 to 1895 Burbank gave much attention to walnut trees, producing the Paradox walnut in 1893, which matured in 15 years instead of the normal 50 to 60 years.

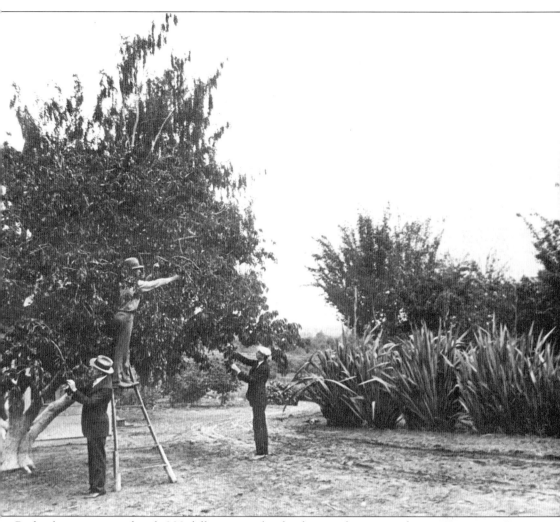

Burbank experimented with 200 different new kinds of sweet cherries on this one "nurse tree" by means of multiple grafts, which resulted in quick fruit production. Between 1900 and 1914 he introduced 10 new varieties of cherries. At one time 40,000 Japanese plum tree seedlings were growing at Gold Ridge Farm, and from these seedlings Burbank produced 113 varieties of plums and prunes. The Satsuma, released in 1887, was highly popular as was his famous Santa Rosa plum. By 1901 Burbank's plum varieties were sold around the world.

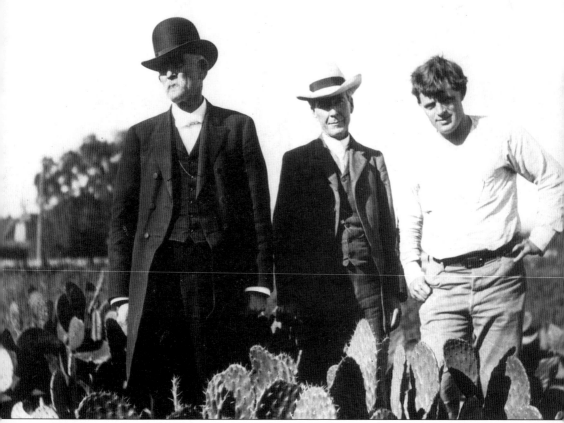

Visitors to the Gold Ridge Farm in this 1908 photograph included, from left to right, astronomer Edgar Lucien Larken, Burbank, and author Jack London. Burbank's renown as a "gardening genius" made him world famous, and he was said to have been the most photographed man of his day. Burbank's work stimulated a worldwide interest in plant breeding, and during his long career he received countless visits from the rich and famous of many nations. Noted visitors included American icons Henry Ford, Thomas Edison, Harvey Firestone, Helen Keller, President Taft, and conservationist John Muir.

One of Burbank's best-known and loved creations is the Shasta Daisy and it is fitting that in 2001, on its 100th birthday, the City of Sebastopol named the Shasta Daisy the official city flower. Seventeen years of cross breeding began with the New England wild daisy crossed with two European species, and finally a Japanese species, producing the pure white daisy in 1901. It has proved to be one of the most popular flowers in American gardens ever since. (LBHG)

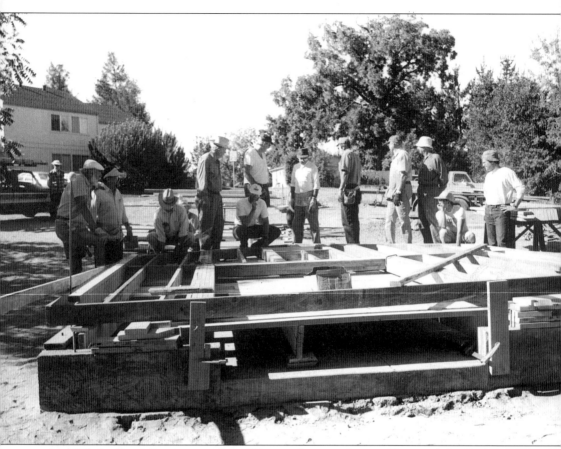

In 1997 the Farm Committee of the Western Sonoma County Historical Society once again put their talents to hard work. Burbank's original barn at Gold Ridge farm had burned in 1967, so using an old photograph of the barn as their construction guide, the volunteers rebuilt the barn and attached greenhouse.

Five
OUR DIVERSE COMMUNITY

Irish immigrant Jasper O'Farrell, educated as a civil engineer, came to San Francisco in 1843. His expertise as a surveyor earned him land in Marin County that he traded for two Mexican land grants: the Estero Americano and Canada de Jonive. Comprising over 19,000 acres, these grants offered some of the finest farm land in Sonoma County. After statehood was granted in 1850, O'Farrell's rancho was organized into a township, which he named Analy Township. In the next 100 years, immigrants from around the world came to Sonoma County looking for work, land, and a new start. Italians, Chinese, Japanese, and Portuguese all came looking for a new life and found it here.

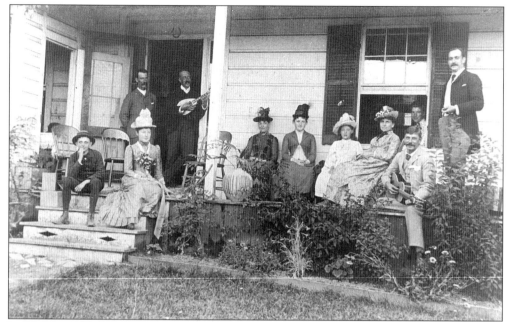

In 1849 at age 32, O'Farrell married Mary McChristian, whose father, Patrick McChristian, was an original member of the Bear Flag Party. The O'Farrells reared eight children at their Analy Ranch. Here, O'Farell's oldest daughter, Elena, is seated on the steps along with a gathering of family and friends. Elena never married and died in San Francisco at the age of 80.

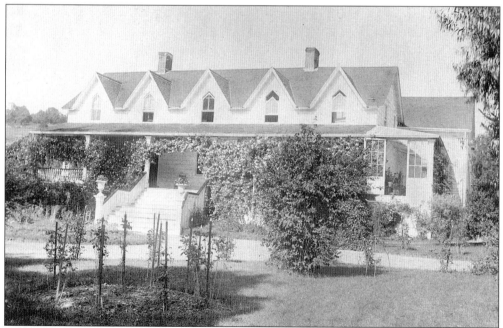

Jasper O'Farrell's home, seen here as it appeared in the 1880s, was built around 1850 on his Analy Farm and sported 32 rooms. After O'Farrell's death, his sister Theresa Wensinger repurchased the ranch from the bank in 1877, and his daughter Elena had it rebuilt after the San Francisco earthquake in 1906. The home was finally demolished in the 1960s.

Kentucky-born Maj. Isaac W. Sullivan was one of the first settlers in Green Valley (Graton) when he arrived here in 1850 as part of the Gilliam wagon train from Missouri. Sullivan purchased 640 acres of land for $800 from Capt. Juan Cooper, brother-in-law of General Vallejo, who was the grant holder to the Rancho El Molino. Other recently arrived settlers to the area during these early times were the Gregsons, the Marshalls, and the Churchmans.

Mary "Polly" Gilliam met Major Sullivan in the spring of 1850 on the wagon train journey to California, and they married in August of that same year not long after they arrived in Green Valley. It was the first wedding held in Analy Township. She was 18 and the major was 43. They reared 11 children and had a devoted and happy marriage that lasted until Polly's death in 1885 at age 52.

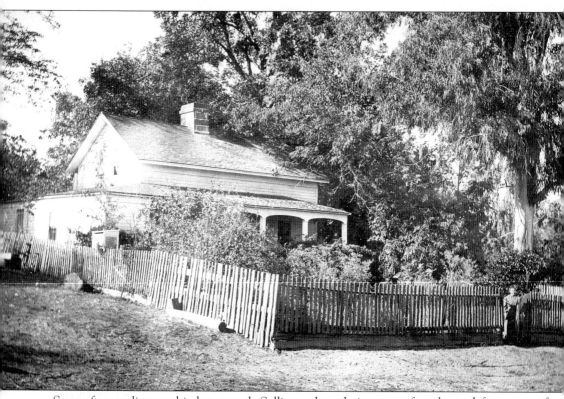

Soon after settling on his homestead, Sullivan planted six acres of apples and four acres of peaches—one of the first orchards in the area. He purchased potatoes to plant from Jasper O'Farrell and James Watson of Bodega. By 1861, Sullivan built a new house to replace the original homestead cabin. Large stone blocks were purchased from the Stony Point Quarry for the foundation, fireplaces and stone entrance. In the late 1870s, the Sullivans built four large fish ponds on the ranch in hopes of selling the fish in San Francisco, but their venture was not profitable. In 1903, long after both the Major and Polly were deceased, the Major's second daughter, Nancy Sullivan Crabtree, purchased the Sullivan house from her brother James Sullivan. Although the deed listed the selling price as a "$10 gold piece" it is likely that was not the true price.

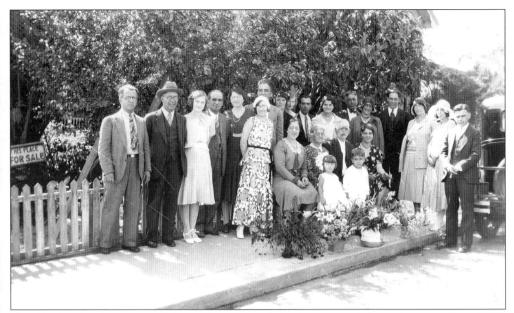

The Borba family emigrated from the Azores Islands and settled in Sebastopol in 1893. Patriarch Manuel Borba found employment as an expert pruner, earning $1 a day in the orchards. Manuel and Jennie Borba had 11 children who all became prominent business people in Sebastopol. This family portrait, c. 1930, shows Jennie and Manuel seated behind the two small children. Manuel died in 1934 at the age of 81.

One of Manuel and Jennie Borba's sons, William (Bill) was just 22 years old in 1908 when he opened his own stationery store in Sebastopol on North Main Street. He soon became the dealer for Victor talking machines, sold radios and Kodak cameras, and was affectionately nicknamed "Radio Bill." Bill was interested in local history and gathered a large collection of Sebastopol photos and memorabilia.

Portuguese Americans who settled in Sebastopol brought from the Azores the Catholic celebration of the Feast of the Holy Ghost. This festival was started centuries ago in honor of Queen Isabel of Portugal, who during a time of great famine fed her people and whose faith in the Holy Ghost was unwavering. The long celebration culminates with a "feast" of beef and bread representing Isabel's gift, and young women from the congregation are chosen to represent Queen Isabel and her court. Claudia Gonsalves (seated) is crowned queen, c. 1950, at the Holy Ghost Hall in Sebastopol. (GDR)

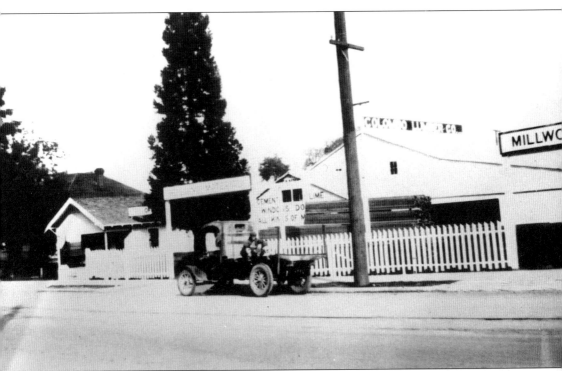

Italians have immigrated to the Sebastopol area since the 1870s in search of work, first finding it in the lumber mills north of Occidental, peeling the bark from tanbark trees to ship to nearby tanneries. They were expert charcoal makers, or *carbonari*, and had a virtual monopoly of the charcoal production in the Occidental area. Italians also worked in the hop yards and in the vineyards, while Swiss Italians worked mainly in the dairies. John E. Colombo, a partner in a lumber company in Santa Rosa in 1920, owned a dairy farm and then owned and operated Colombo Lumber in Sebastopol from 1923 until 1978. The lumberyard, located on South Main Street at Palm Avenue, was demolished in 1990. (JC)

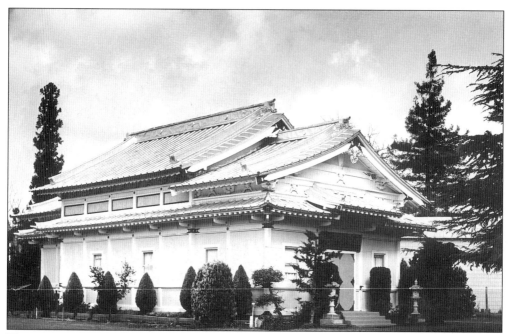

The unique Enmanji Buddhist Temple of Sebastopol, originally built by the Manchurian Railroad Company for the Chicago World's Fair in 1933, faithfully represents a 12th century Kamakura-style Japanese temple. After the fair it was offered to the members of the Sonoma County Buddhist Temple, and the structure was dismantled and shipped by rail to Sebastopol for reassembly. (ET)

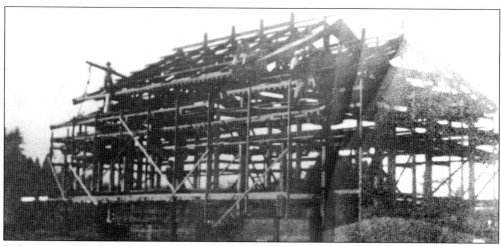

In January 1934, skilled local Japanese craftsmen began reassembly of the temple, which was constructed without the use of nails. This is the temple as it appeared in February 1934 during reassembly. (ET)

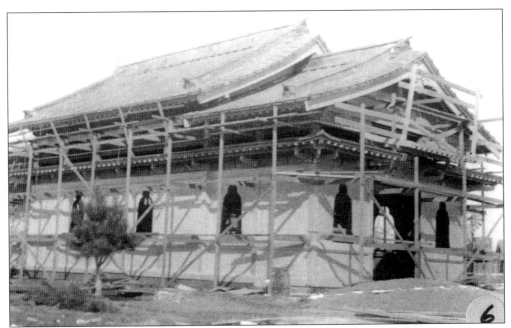
One month later, in March of 1934, the temple is nearing completion. (ET)

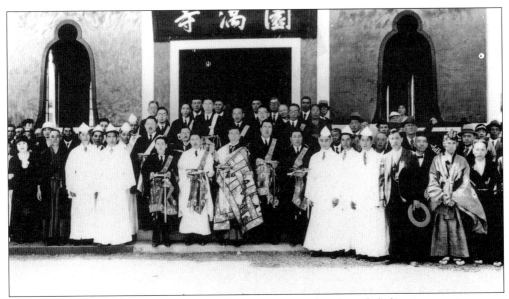
The Enmanji Buddhist Temple reconstruction was completed, and dedication services were held on April 15, 1934. In 1953 an adjoining Memorial Hall was built by temple members in honor of three Americans of Japanese ancestry from Sebastopol who died in the service of America during World War II: Leo Kikuchi, Peter Masuoka, and Joe Yasuda. (ET)

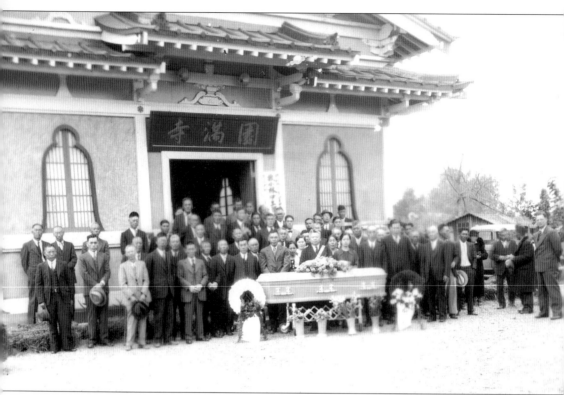

Enmanji Temple was boarded up during the war years. It suffered at the hands of vandals and arsonists, so members of a local Christian youth group took responsibility for guarding the temple to prevent further damage. In 1947, repairs were made to the temple, and at that time the bell-shaped window frames were replaced with rectangular ones. Members of the community are seen here gathered for a funeral service at Enmanji Temple sometime in the late 1930s or early 1940s.

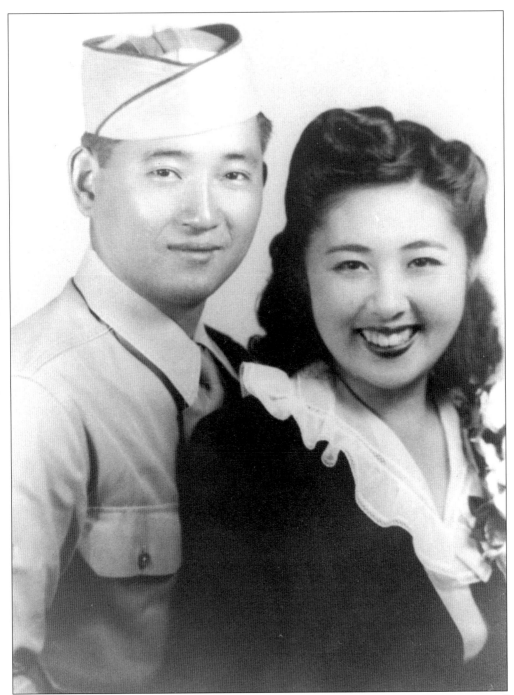

All Americans of Japanese ancestry in Sebastopol were removed from their homes in 1942 and forced to live in concentration camps for the duration of the war. Japanese Americans from Sonoma County were sent to the Amache Relocation Camp in Colorado. Sadao Hamaoka (left) and Shizue Fujihara Hamaoka met at Camp Amache and were married there in 1944. They returned to Sebastopol after the war where they reared their two sons and where Sadao worked at the Hotle-Burdo Ranch for 50 years. (SH)

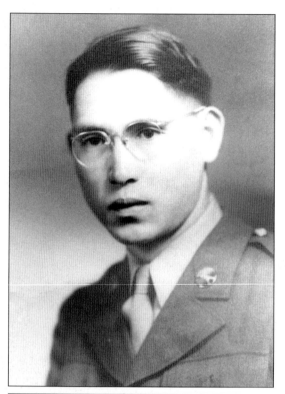

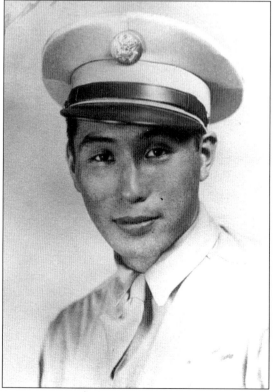

Americans of Japanese ancestry Leo Kikuchi (top) and Peter Masuoka (bottom) were graduates of Analy High School. Masuoka, senior class president from the class of 1940, was the first American of Japanese ancestry to receive the American Legion Citizenship Award in Sonoma County upon his graduation from high school. Both Kikuchi and Masuoka joined the famed 442 Regimental Combat Team made up of Japanese-American volunteers. The extraordinary courage of the men of the 442nd made it the most decorated unit in U.S. military history. Private Kikuchi was killed in action in Italy, and Staff Sargeant Masuoka was killed in action in 1944 in France; Masuoka was awarded the Silver Star medal posthumously. His parents were notified of his death while still interned in the Amache Relocation Center in Colorado. (LK and MM)

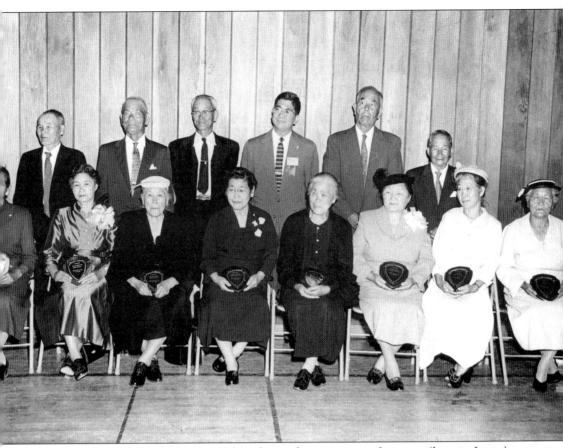

The Issei Pioneer Night took place in 1953 to honor first-generation Japanese (born in Japan). The event was sponsored by the Japanese American Citizen League. Pictured here are, from left to right, as follows: (front row) Shina Murakami, Yumi Shigematsu, Mrs. Matsuda, Chika Matsumoto, Umeno Morita, Tsuya Fugihara, Mrs. Kai, and Tamano Kai; (back row) Ichitaro Shigematsu, Mr. Matsuda, Waichi Matsumoto, Mike Masaoka, Saikichi Fugihara, and Mr. Kai.

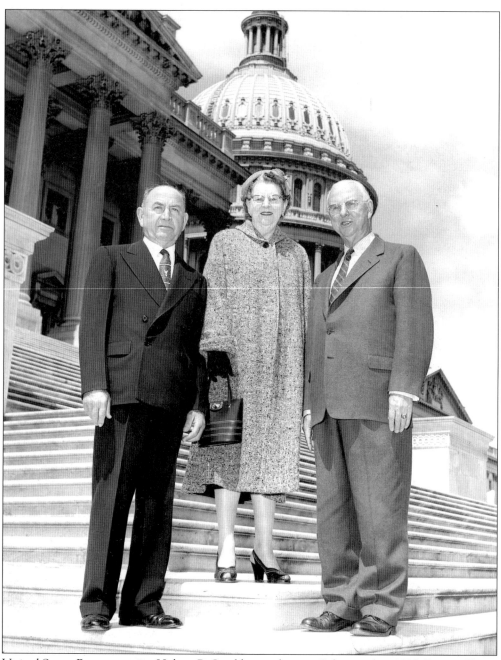

United States Representative Hubert B. Scudder was born in Sebastopol in 1888. Pictured here, from left to right, are Scudder's brother-in-law, Scudder's sister, and Scudder himself. As a young man he worked as a painter for Joseph Naumann at the Sebastopol Paint Store, and during World War I he served in the U.S. Army. Scudder was elected Sebastopol city councilman in 1924 and mayor in 1926. From 1925 until 1940 he was a member of the California State Assembly, and in 1948 he was elected U.S. Representative from California and served five terms.

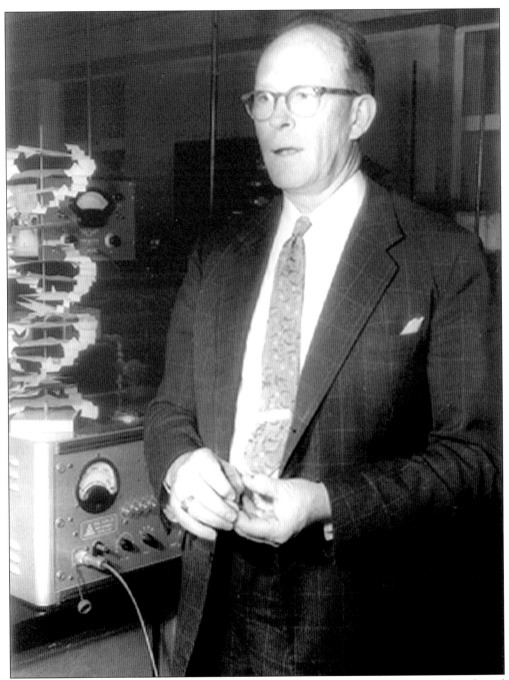

Dr. Willard F. Libby, who won the 1960 Nobel Prize, was reared in Sebastopol and graduated from Analy High School in 1926. The son of an apple rancher, he was an honor student and student body president of his class. Libby earned a Ph.D. from Berkeley in 1933 and during World War II he worked on the Manhattan Project, which led to the development of the atomic bomb. In 1960 Libby was awarded the Nobel Prize in chemistry for his discovery of carbon 14 dating. In June 1976, Libby attended the Class of 1926 50th reunion at Analy High School and was honored with the dedication of a new science wing named in his honor. (UCLA)

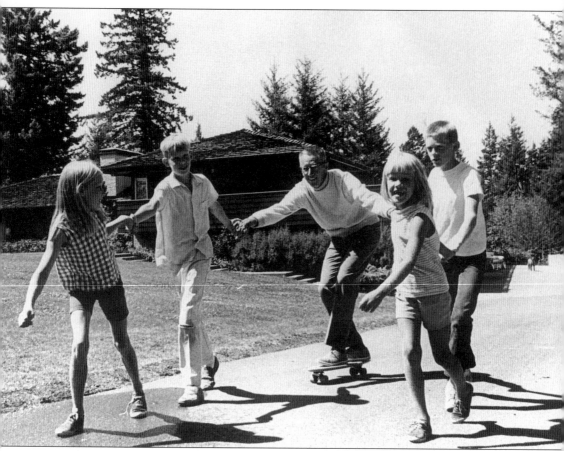

World famous *Peanuts* cartoonist Charles Schulz was a Sebastopol resident from 1958 to 1968. Charles, his wife, Joyce, and their five children lived on Coffee Lane west of town. Shulz is pictured at their Sebastopol house with four of his children, from left to right, Amy, Craig, Jill, and Monte. Schulz's oldest daughter, Meredith, is not pictured. In 1966 a devastating fire destroyed Schulz's Sebastopol studio. (SMRC)

Six
MORE HITHER THAN YON

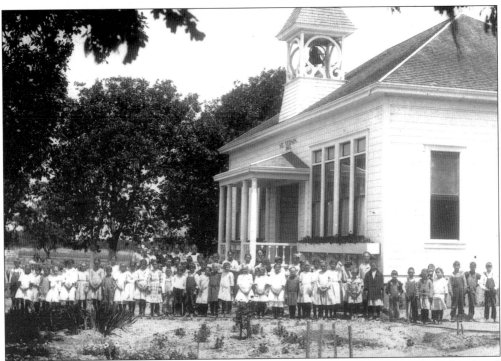

Sebastopol is surrounded to the north, west, and south by small country towns, which developed around early stagecoach stops and, later, along the railroads. Cunningham Station was a stop along the P&SR Railroad named for John and Mary Cunningham, immigrants from Belfast, Ireland, who settled four miles south of town in 1882. Dairy cows and orchards were raised on their 275 acres, and the Mt. Vernon School was established in 1903 on adjoining property.

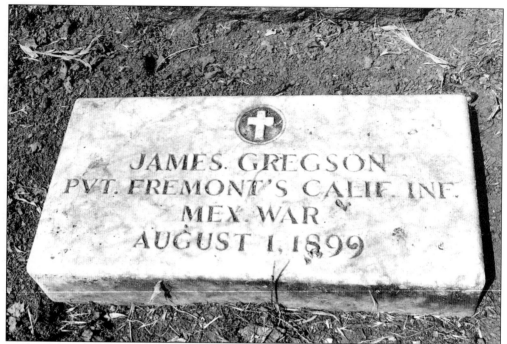

James Gregson settled in Green Valley in 1850, and soon thereafter, more land was claimed by Mitchell Gilliam, Isaac Sullivan, Lancaster Clyman, and Patrick McChristian. The first commercial orchards were planted about 1853, and the first hops in the county were planted by Amasa Bushnell and Otis Allen in 1858.

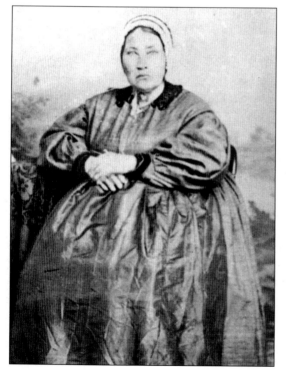

This photo, taken about 1870, shows Rachel Ernest Taylor, who was Mary "Polly" Gilliam Sullivan's grandmother. She was born in South Carolina in 1798, died in 1881, and is buried in the Gilliam Cemetery in Green Valley.

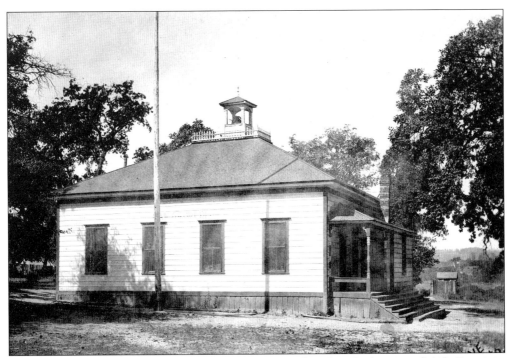

The first public schools in Somoma County were Dunbar, Los Guilucos, and Ash Spring in Green Valley (which later became Oak Grove). In 1852 there were 250 students in attendance at five schools in the entire county. In 1855, the county superintendent of schools reported that there were 1,253 children enrolled in 23 schools. Oak Grove School (shown above) was built in 1854 on Gilliam property.

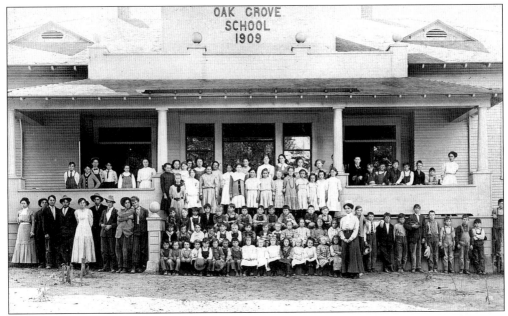

In 1866, Green Valley School was built, only to burn down and be rebuilt in 1929. By 1909 a new Oak Grove School (shown above) had been built in nearby Graton. This photo was taken in 1911.

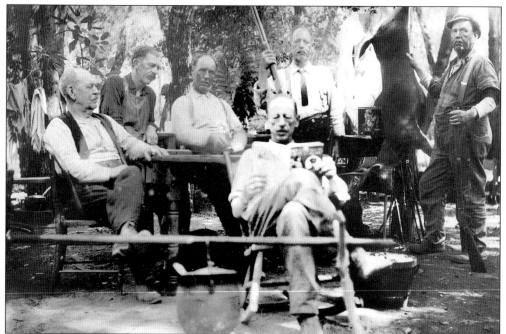

Maj. Isaac Sullivan was a prominent early settler in Green Valley and is credited with the first manufacturing for export in Sonoma County. Among other things, he developed and sold chairs that were later known as Forestville Chairs. His six sons are shown relaxing after a hunting trip. They are, from left to right, Neal, Charlie, Jim, Asa, Wesley, and Ben.

The year of 1899 was a busy one for the new church in Green Valley. The Methodists constructed a new building in Peachland, with the Reverend C.E. Irons as pastor. Trustees were James Gregson, Benjamin Williams, H. Lapum, and Isaiah Thomas. The Green Valley Congregational Church, with Mr. Rogers as minister, built a new church that same year. Here, berry pickers from Barlow ranch attended services on Sunday during berry harvest season. (B)

Churches played social as well as religious roles in the communities, hosting a variety of activities throughout the year. Here in 1912, an unknown group at the Graton Congregational Church has assembled elaborate costumes and decorations.

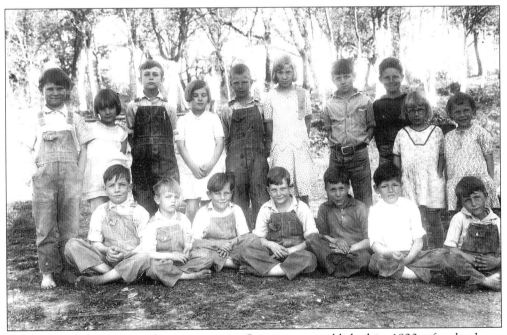

The Pacific Christian Academy campus in Graton was established in 1920, after land was purchased from the Oak Grove School. A building was erected soon after the Marshall school building was purchased, and moved from its Occidental Road site to be added as a second story to the Academy. In the back row of this 1930 class picture are, from left to right, Jack Blackwell, Neal (?), Harold Narron, Dony K., and Wane F.

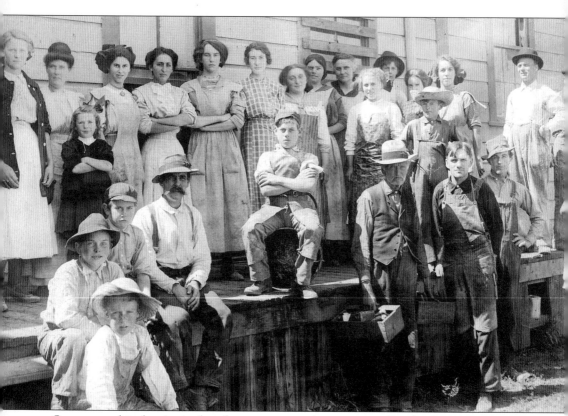

Grapes, peaches, berries, and apples were among the crops raised in the Graton area as early as the last half of the 19th century. Since the establishment of the first packinghouses and canneries, women and young children were a part of the work force.

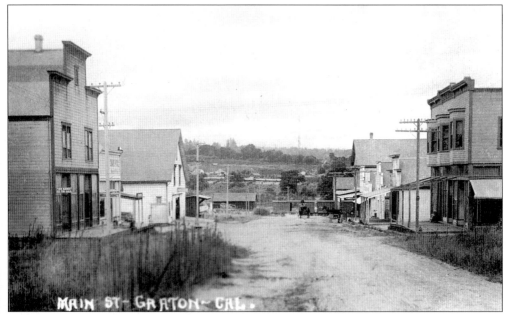

Graton, a part of Green Valley, has been known by many names—some claim as many as 12. Some of the most recent were Peachland, Hicksville, Squirtsville, and New Town. When the P&SR railroad came in 1904, James H. Gray and J.H. Brush were prominent in building up the town and advancing its growth. First called Gray's Town in 1906, the name was condensed to Graton. Pictured here is Graton as it appeared in 1913.

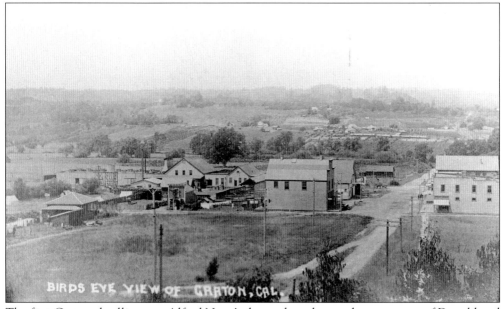

The first Graton dwelling was Alfred Neep's, located on the north east corner of Donald and Brush Streets. John Robertson was the first postmaster when the Graton post office opened in 1906. T.J. "Jeff" Jones established the first grocery store and also ran a lumberyard. After Jones, the store was operated by E. Wilhoit, Hallet and Gray, Charles Hallet, John Spooner, and then Milton Flescher. (GDR)

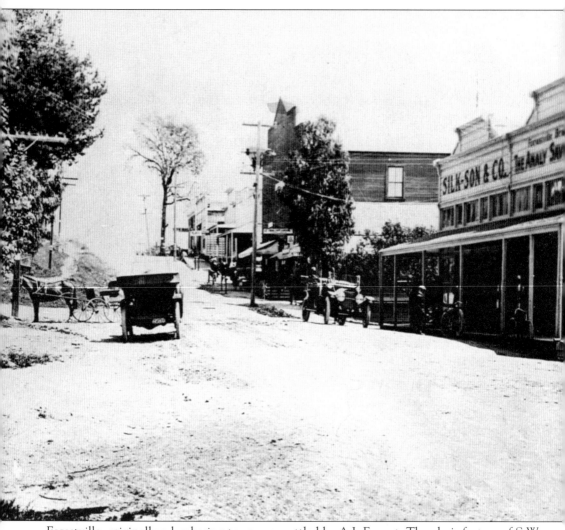

Forestville, originally a lumbering town, was settled by A.J. Forrest. The chair factory of S.W. Faudre was moved from the banks of the Russian River to Forestville and manufactured chairs, originally introduced by Isaac Sullivan. The chairs sold for $5 apiece in San Francisco, joining other important area exports such as hops, apples, and cherries. The Forestville post office was housed in the Analy Bank Building.

The P&SR electric railroad spur ended in Forestville, and the Electric Hotel offered lodging near the railroad station. The town was granted one of the first three rural telephone franchises in the county in 1903.

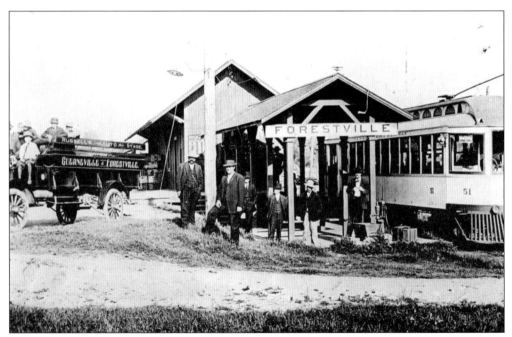

Transportation possibilities expanded quite a bit once the electric line was completed in 1904. Russell's Auto Stage, for example, offered service from Forestville to Guerneville and points in between, along the Russian River.

Freestone developed in 1976 with the arrival of the Northwestern Pacific narrow gauge railroad. Prior to 1976, Freestone only had a post office where the stagecoaches stopped. Ferdinand Harbordt established the first commercial building, a saloon. Jasper O'Farrell owned the rancho where Freestone developed. Prior inhabitants also included Ivan Kuskoff, commandant of Ft. Ross under the Russians, who started a farm in 1812 in the vicinity of Freestone.

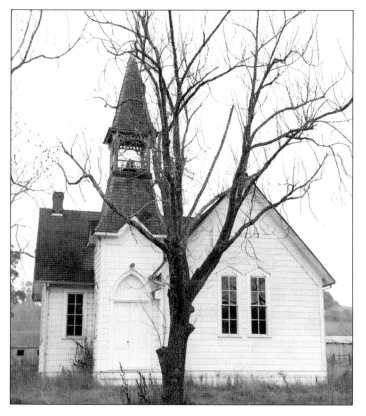

The first house in the town of Freestone (which was named for a quarry of free stone) was a half-cabin, sawn in two and moved to the site by an ox team. This unusual arrangement was James Dawson's solution to a disagreement with his partner, Mr. McIntosh, about title to the land. In 1920, the county built concrete roads from Sebastopol to Freestone and water-bound macadam roads from Freestone to Valley Ford. Freestone's Methodist church was built in 1870.

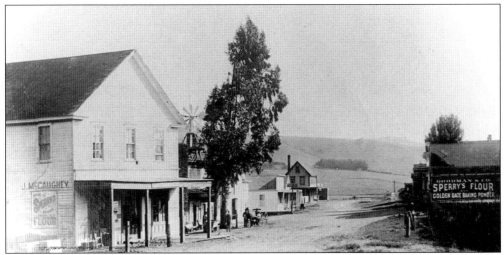

In the 1840s Captain Stephen Smith brought the first steam-powered sawmill to Sonoma County. In 1879, Bodega boasted of two general stores, three hotels, one livery stable, one meat market, a blacksmith shop, a wagon maker's shop, two shoe shops, three saloons, two physicians, a millinery shop, and a barbershop. McCaughey Brothers general store was located in Bodega from 1866 until 1985. Downtown Bodega is pictured above.

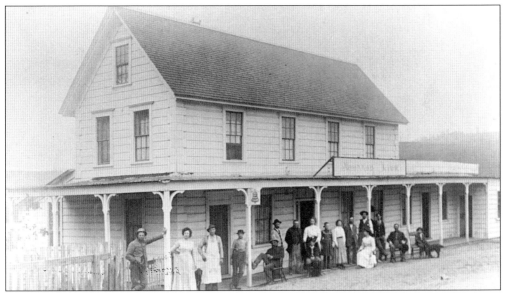

One day in the 1870s, the Murray House was decidedly non-peaceful when a steer broke away from butcher, Cyril Cazeres. The animal ran down the street with Cazeres, along with the town's male population, in hot pursuit. Finding the lobby door to the Murray House open, the steer dashed in, up the stairs, and out a window, landing on the porch roof. Reportedly the roof was more damaged than the steer.

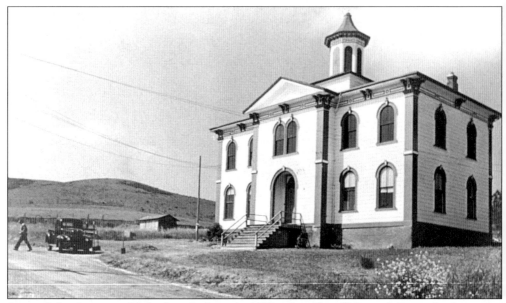

Potter School was established in Bodega in 1873, after Sheriff Samuel Potter built it on a portion of his ranch. Classes continued there until 1961, and later it was used as a setting in the filming of *The Birds*, released in 1963. The schoolhouse was slated for demolition before the making of the movie, but has since become a popular tourist attraction. It stands across the road from the old Druid Hall.

The first Mass in Bodega was celebrated by Father Rosse in March 1860. This occurred in the schoolhouse that preceded the Potter School. St. Teresa's Catholic Church was erected later that year on Jasper O'Farrell's property and was central to the extensive parish that included Healdsburg, Santa Rosa, and Bodega.

Camp Meeker was built by mill man M.C. "Boss" Meeker in the heart of the Occidental redwoods. Advertising in San Francisco, Oakland, and Alameda newspapers, Meeker sold 70 lots in 1898. Camping was available, with a lake for boating. During the spring and summer of 1899, 1,400 people were guests at his camp. The Northwestern Pacific Coast Railroad ran through the 50 acres. In 1900, Meeker sold the property to Henry Gregson.

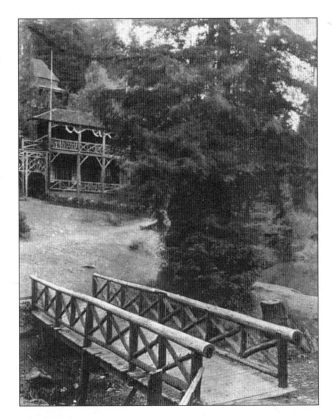

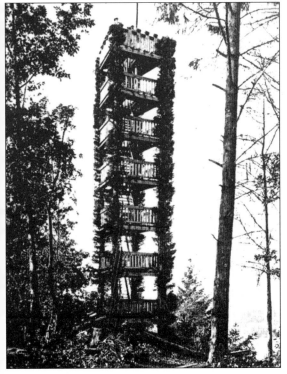

Meeker built the "Living Tower" to add to the attractions of Camp Meeker. Platforms were built connecting four redwoods to form the tower. It is said that on a clear day, five counties were visible from the top. At the time that the Living Tower was torched in the 1940s the trees were reported to have become quite bushy.

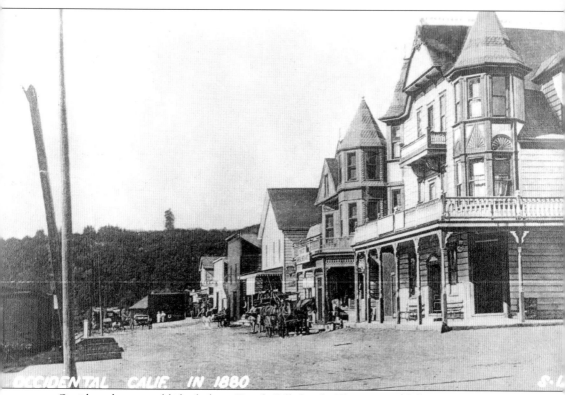

Occidental was established along Dutch Bill Creek. There was a difference of opinion in this Northwestern Pacific Coast Railroad community about the naming of the town. Should it be Howard's Station, named for William Howard, or Occidental? Eventually Occidental prevailed and became a thriving town, fueled by the lumber industry. Fire almost completely wiped out the community in 1899, however. In this photograph Occidental is shown as it looked in 1880.

Seven
SLATES AND PRAYER BOOKS

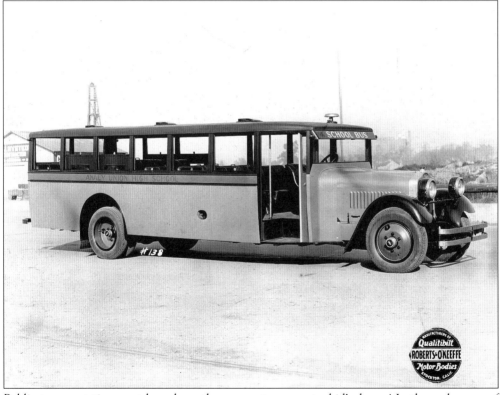

Public transportation must have been the answer to a country kid's dream! In the early years of school attendance, children walked, rode horseback, or got a ride on the family horse and buggy/wagon. Later some caught the train, but it was not until 1925 that the first school bus was made available to students of Analy High School.

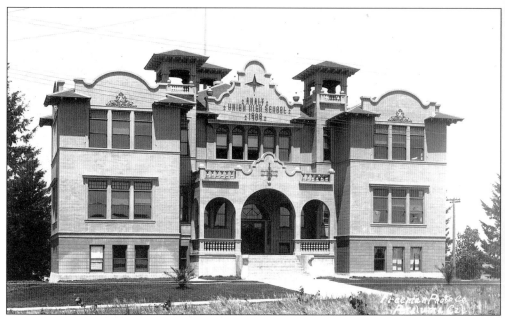

Before there was a high school in Sebastopol, students attended Santa Rosa High, Tomales High (where they boarded by the week), or did not go to high school. When Analy Union High School was established in 1908, the first students attended classes in part of Sebastopol Grammar School. The high school building was completed by the second week of school in September 1909.

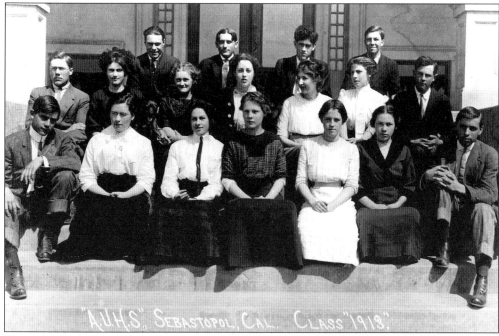

These Analy graduates from the class of 1913 are ready to face their future. They have studied Latin, German, English, science, physics, history, and physical geography. Agriculture, commerce, and drawing were also a part of the curriculum. Debate Club, girls' and boy's basketball, boy's baseball, and dramatic productions kept students busy.

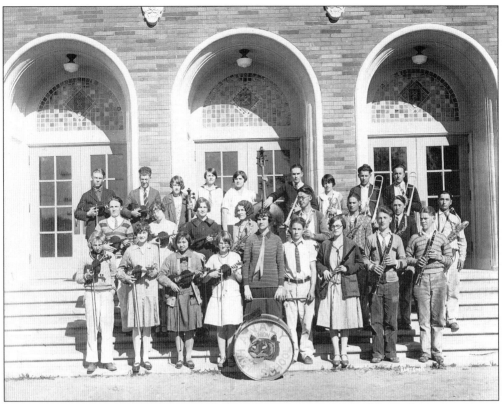

The curriculum was enriched by including a music class, clubs, and additional sport teams.

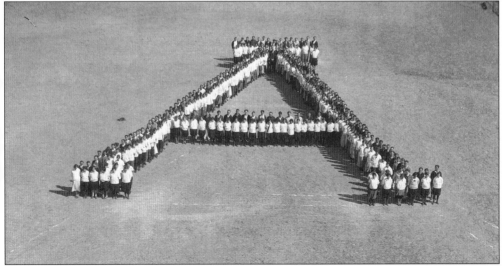

School spirit abounds! The Analy Tiger has been chosen as school mascot and blue and white to serve as school colors. Here, the entire Analy student body is assembled in a display of school pride.

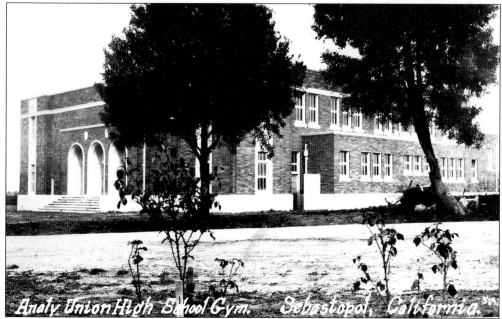

The original gymnasium was a wooden structure, erected at a whopping cost of $1,075, and was replaced by a brick structure in 1927. W.H. Weeks was the architect credited with the 1927 design. The new gym served the school until it was demolished in the 1970s to make room for the school's Willard Libby Library.

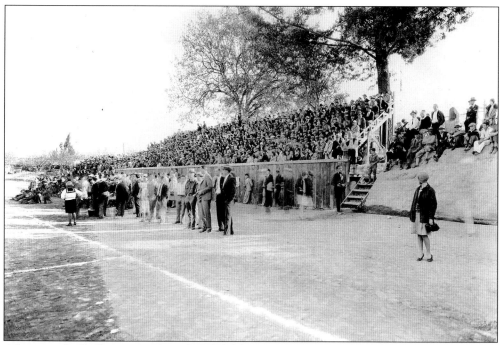

Afternoon football games and track and field events were always well attended on the Analy field. Overflow seating was provided on the bank if the bleachers were full, as was the case at this 1925 event. In 1951, field lighting was installed and night games became a reality.

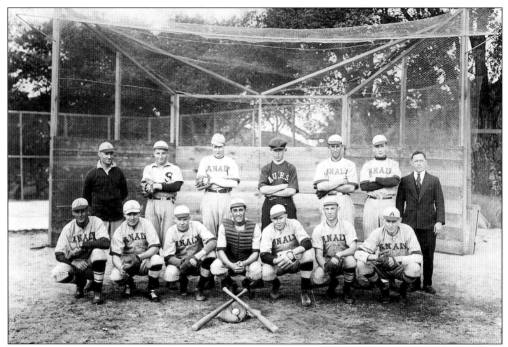

Analy's 1921 baseball team was undefeated in the regular season, losing only to Chico in the North Coast California Interscholastic Federation championship. Team members, from left to right, are as follows: (front row) Ansil Bullelli, Al Collins, Carl Williamson, and Fred Jenssen; (back row) Ted Woolsey (coach), McCormak, T. Talbot, Ace Sullivan, Rolo Winkler, Fred Bushner, and William Baker (coach).

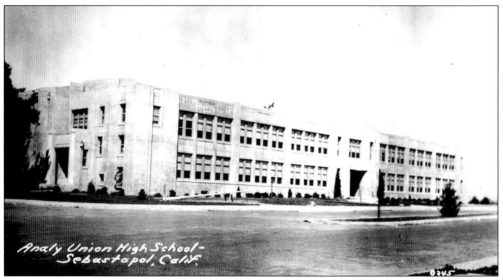

The school population from Sebastopol and outlying areas gradually increased. By 1935 a new school was built as a WPA project on the same site as the original school, serving students that were bussed from all the outlying communities, the Russian River area, and as far away as Cazadero. That was the case until El Molino High School was built in 1965. El Molino opened with 300 students, leaving Analy an enrollment of 1,550.

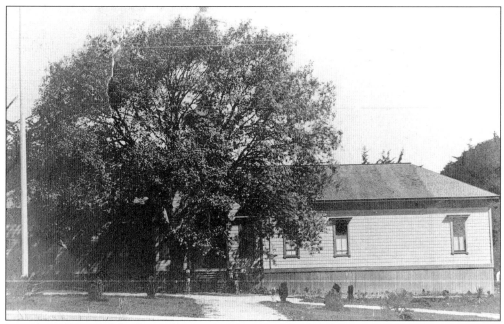

Lincoln Hall housed the first Sebastopol Grammar School at the site of the present Sebastopol library. It served as an auditorium, gymnasium, and later as a meeting hall when the school no longer had need of it. (GDR)

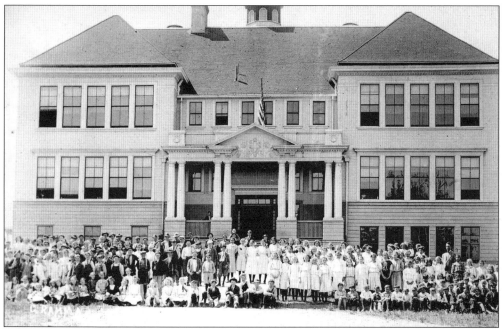

Over 100 enrolled in Sebastopol Grammar School when school opened for the fall term in 1895, and many more were expected once the hops were harvested (by 1912 the enrollment was 348). In 1897 district voters rejected a tax measure to add a story to the existing school. The photo shows the second story in place in 1910. Park Side School was built by WPA funds in the early 1930s.

Near the turn of the century, rural schools appeared all over the western county. When transportation improved, school districts began consolidating, and by 1920 Marshall and Llano schools had joined with Sebastopol Grammar School. Spring Hill (below), established in 1872, and Pleasant Hill (above), built in 1865, consolidated as the Twin Hill District in 1958. As the school buildings were no longer used some were sold and moved to other districts, some were abandoned, and others converted to residences.

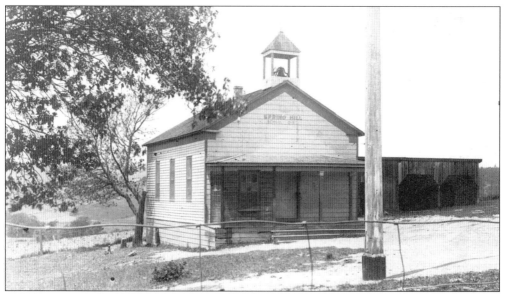

At one time, graduation from grammar school required a written examination, given by the board of education in Santa Rosa, over a three-day period of time. Because of distance, expense, and lack of opportunity to attend high school, few country pupils took the exam. The rule was changed in 1886, when students were allowed to be examined in their home school.

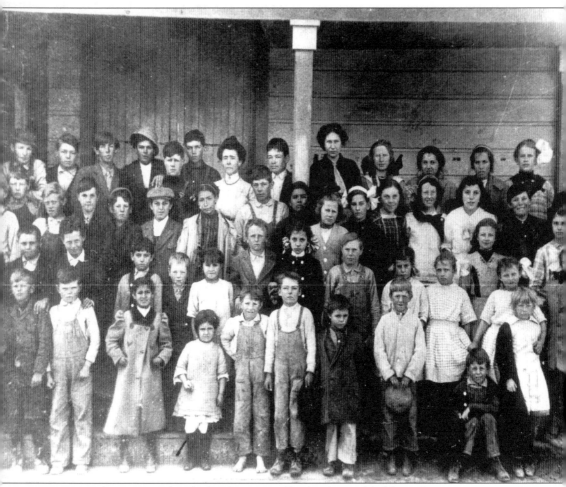
In 1912, the entire student body of Spring Hill School assembled for a photo opportunity. Some of these students had to walk long distances to attend school, but they did so stylishly. Pictured here are a wide variety of fashion statements typical of the era, from fine hats to bare feet.

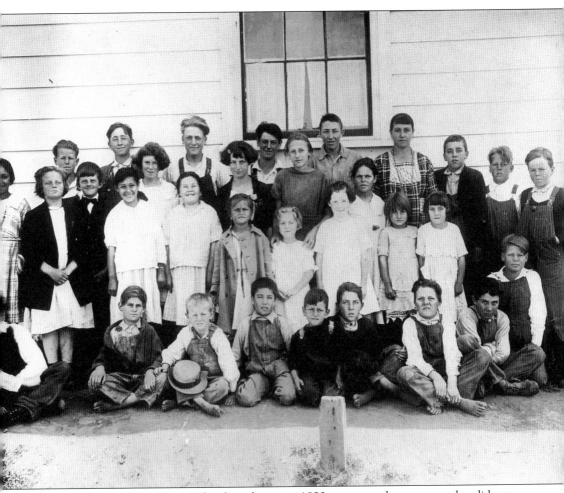

This group photo of Freestone School students, c. 1923, suggests that some styles did not change, particularly for boys. Bare feet, bib overalls, and the occasional hat were seen long after little girls went to short dresses and bobbed hair.

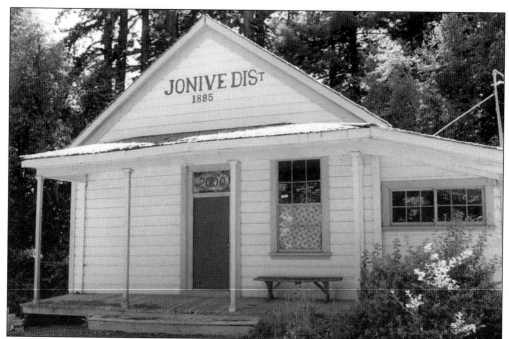

Sonoma County had five "rancho" schools in 1852. Three of those districts—Jonive, Sonoma, and Santa Rosa—were conducted in English, while the schools in Bodega and Mark West were conducted in Spanish. Jonive School was built in 1883 on property belonging to Jasper O'Farrell, on part of what had been the Canada de Jonive land grant.

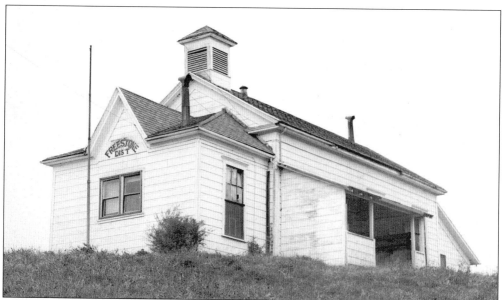

Freestone School, also built on O'Farrell property, was situated on the western foot of O'Farrell Hill. When the school was built in 1852, it was situated half-way between Old Town and New Town Freestone, a long walk for students coming from the other side of the hill. If they faced an arduous hike, parents sometimes kept young children out of school until they were seven or eight years old.

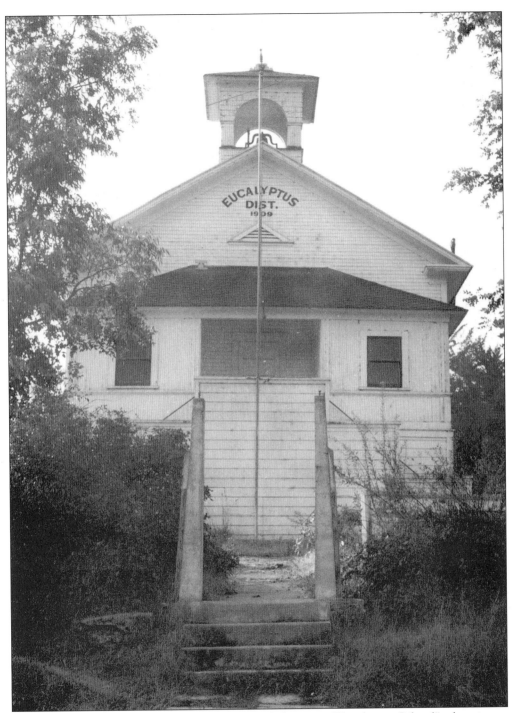

The setting of trees on the Hessel ranch inspired the name "Eucalyptus School" when it was established in 1909. Most rural grammar schools were built with one classroom, and more were added as needed. The three country schools south of Sebastopol operated from early in the twentieth century until the mid-1950s. Mt. Vernon (established in 1903), Gold Ridge (built in 1916), and Eucalyptus consolidated to form Gravenstein School District.

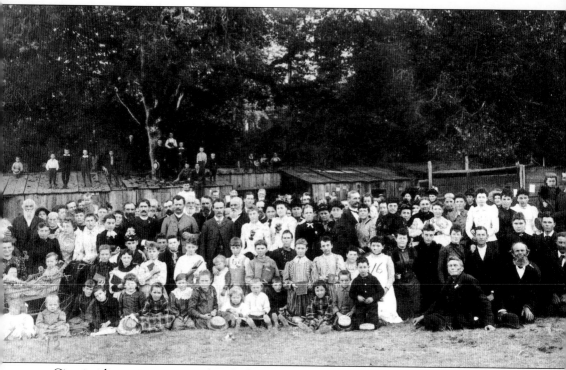

Circuit riding ministers, traveling by horse or mule from town to town, were among the first to bring organized religion to western Sonoma County. The Bodega Circuit district brought religious views to Petaluma, Sebastopol, Santa Rosa, Healdsburg, Mark West, and Macedonia. For a yearly salary of $75 in 1857, the minister would preach services, hold prayer meetings, perform weddings, christen babies, and conduct funerals. The Reverend Richard Williamson served in that capacity for the Methodist Church in the late 1850s. Ministers also rode for the Southern Methodist, Cumberland Presbyterian, the Disciples of Christ, and the Adventist Churches. Camp meetings were started as a result of the same isolating circumstances that affected towns, specifically the distance between settlements and lack of transportation. A number of ministers and members of various churches throughout the county would gather for week-long camp meetings, the importance of which was social as well as religious. Depicted here is a gathering at a Green Valley camp meeting in 1892.

Three buildings have housed Sebastopol's Methodist church at the corner of Main Street and Healdsburg Avenue. The first was a 40-by-60-foot wooden structure which was built in 1867 and burned in 1896. Rev. J.C. Bolster conducted services in a tent until the next building was completed in 1897, only to be destroyed by fire in 1914—the work of a suspected arsonist.

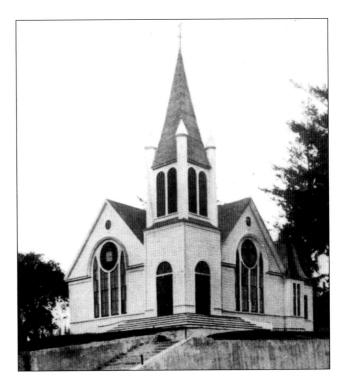

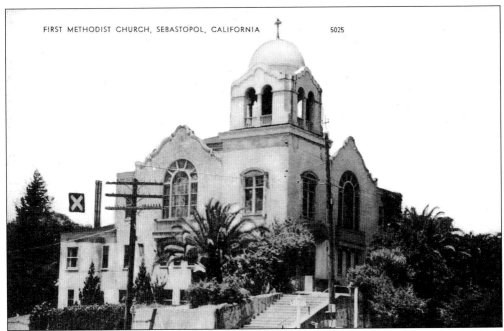

The Woman's Christian Temperance Union, which was organized in 1880, met in churches and preached against the twin evils of alcohol and tobacco. Was it mere coincidence that Sebastopol Methodist, Occidental Methodist, Green Valley Congregational, and Sebastopol Congregational churches all burned within the year of 1914? The existing First Methodist church in Sebastopol was built in 1915.

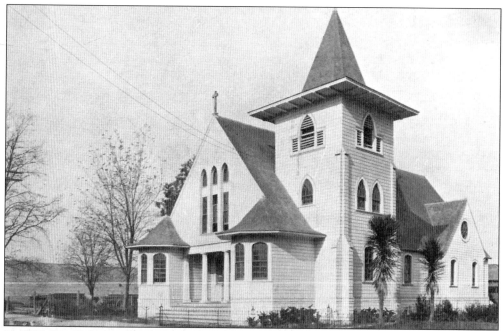

In 1895, the Catholic church was built on a site donated by Mr. and Mrs. John A. Brown. The church was "opposite the Layton cottages on Bodega Avenue, near the depot," referring to the Northern Pacific Railroad that opened a line from Santa Rosa to Sebastopol in 1890. The congregation raised $3,000 for the construction of the building.

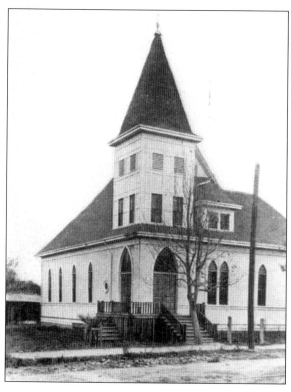

In 1875, the Sebastopol Congregational Church shared a minister with Green Valley. The congregation of 19 met first in the old Rayburn Store on Main Street and Bodega Avenue and later moved to North High Street. Charles Kirkland was the first minister. By 1894, the new church was built on the site of the present Analy Funeral Home. After suffering heavy loses by fire in 1914, it was remodeled and rebuilt.

Eight
IN OUR SPARE TIME

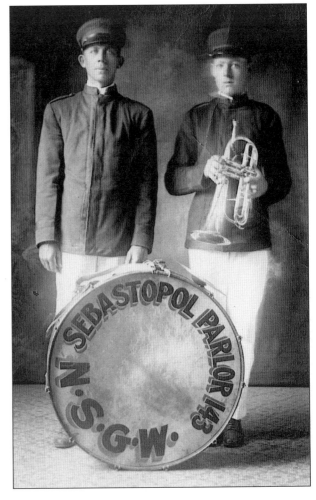

Gen. Albert M. Winn, a Virginian who came to California in the Gold Rush, organized the Native Sons of the Golden West in 1875. Sebastopol's Native Sons Parlor #143 was established in 1902. Winn wanted to create an organization as a monument to the fortitude of the men and women pioneers who emigrated to California. In this photograph, Henry and Leonard Owens are ready to represent the Native Sons musically.

The George Baxter house on Gravenstein Highway South was built in 1892 on the former Martin Litchfield ranch. George Baxter was cashier of the Bank of Sebastopol, organized in 1892. The house was once the dental office of Cuthbert E. Malm, then the Chateau Margot restaurant in the 1970s before being remodeled in 1980 into other office space.

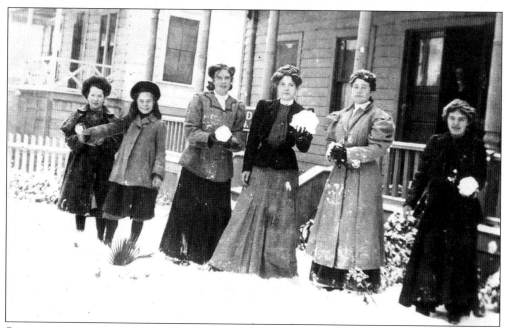

Snow is a rare occurrence in Sebastopol, but it does occur, as seen in this photograph from January 6, 1908. The Strout family, as they frolic in the heavy snow, wisely donned warm clothing to keep remove comfortable.

In 1954, George Smith and his wife, Joyce, bought a 30-acre apple orchard near Graton. Born in Burbank and a ninth-generation Californian, George worked in Hollywood as a set builder and handyman to the stars. On his ranch he began to build "Georgetown" to house his extensive collection of movie and family memorabilia. Beyond Georgetown, George Smith's legacy to Sonoma County is the landscaping he created at Sonoma State University. (SCM)

A lumber mill was established in Monte Rio in 1877, and later when all the timber was cut, the railroads brought tourists to enjoy the redwoods and Russian River, where they stayed in tented cabins or at hotels. The Monte Rio Hotel was the most distinguished, as it rose seven stories and was built into a hill. The hotel was torn down in the late 1930s and the redwood lumber salvaged.

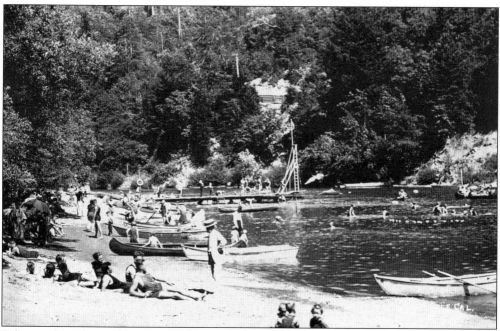

Sebastopolians have always enjoyed boating and swimming in the Russian River, but even at the turn of the 20th century, San Franciscans established the summer vacation tradition as they climbed aboard the North Pacific Coast Railroad. This train, which ran from Sausalito to Cazadero, brought vacationers to summer homes or just a week at the beach in the country.

The spirits were quite active on Halloween in 1895, as city signs were removed, wagons were parked on Main Street rather than at homes, city fire equipment was moved to the local bank, and a nursery sign was put in front of the reading room. The "topper" was a buggy hauled up to the roof of Pickering's blacksmith shop.

Every kid has his or her toys, such as this "Irish Mail" or pump car ridden by this child (there are still kits available to make these toys). The Wells Fargo Express wagon would have delivered this child-delighting package, and you didn't need paved sidewalks to ride it.

The Analy theater was built in 1948 and torn down in 1974. An earlier Analy theater, built in 1911, was owned by Albert Huntley and A. Persich and was one of the few sources of entertainment in town. It boasted a stage with scenery and an $1,800 "auto piano." Huntley also operated the Starland Theater, which went out of business when talking pictures were introduced in the 1930s.

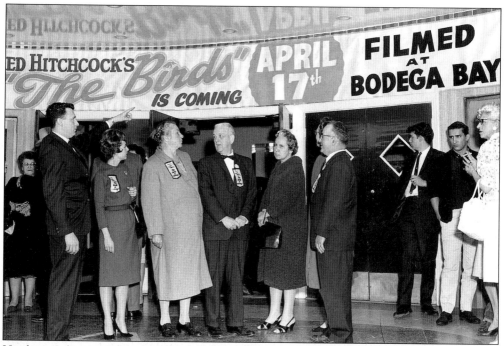

Hitch in Sebastopol? No, but that's Rose Gaffney in the long pale coat attending *The Birds* opening in Sebastopol. Alfred Hitchcock's film was shot in part on Mrs. Gaffney's property at Bodega Bay. Mrs. Gaffney is further known for leading the opposition to Pacific Gas & Electric Company's attempt to build a nuclear power plant at Bodega Head in the 1960s.

We missed the Apple Blossom parades in the 1950s, so Gala Days was instituted in its stead. Here, Glen and Betty Gulick ride in a 1915 Ford in a 1959 parade. Note P&SR Railroad Depot on the left in the guise of Clarmark Florists, a business that occupied the depot for 30 years. The Congregational (Community) Church can be seen in the far background.

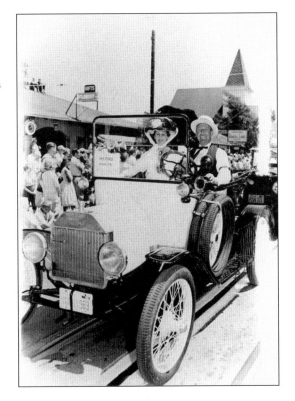

The daughters of Teresa and George Wetch lead the children's section of the Gala Days Parade. If you played accordion, danced tap or ballet, acted, sang, told jokes, or played other musical instruments, you had a chance to show your stuff in Gala Days' local talent variety show.

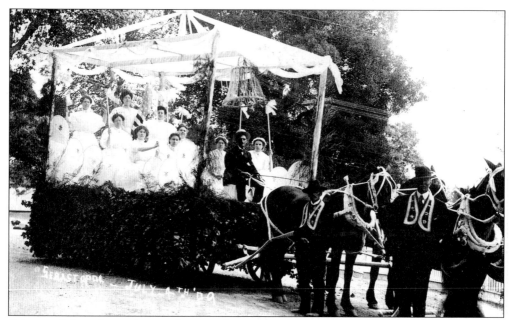

Sebastopol has always known how to throw a parade. In 1902, Towne's Drug Store sold firecrackers, bombs, torpedoes, toy pistols, and fireworks in competition with stores in Chinatown. They also had plenty of ice cream and soda water and a free barrel of ice water in front of the store; that was bound to keep you cool in one way or another.

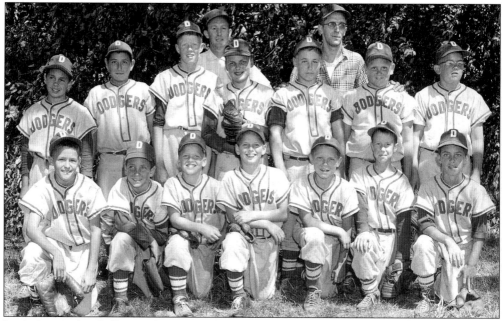

Little League baseball started in 1939 in Williamsport, Pennsylvania, in part to teach boys 12 and under fair play and teamwork through sports. Robert Crowe started Little League in Sebastopol in 1957 with four teams: the Dodgers, Giants, Yankees, and Indians. A minor league played in town as well on a more casual basis; those teams were sponsored by local businesses such as the Sturgeon's Mill Beavers.

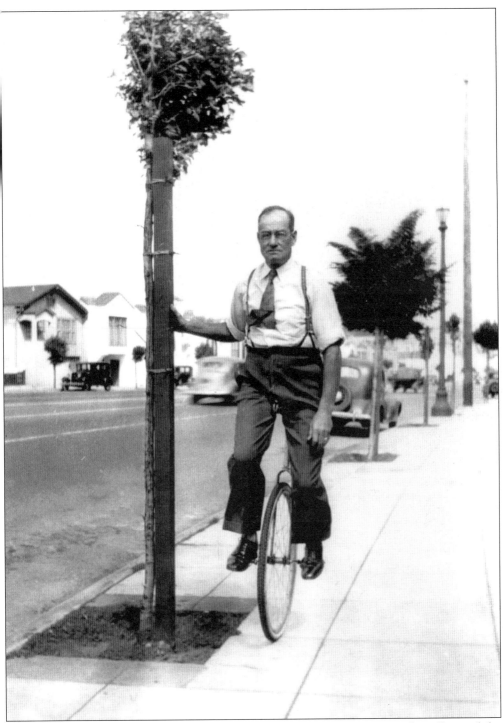

In 1900, William Palmer, then 13, delivered milk around town on his unicycle. Bill joined the Native Sons of the Golden West in 1905 and performed at events, parades, and lodge meetings. Later he moved to Concord, California, where he started a unicycle club in 1945. In 1953 at age 65, he rode his unicycle in President Eisenhower's inaugural parade in Washington, D.C.

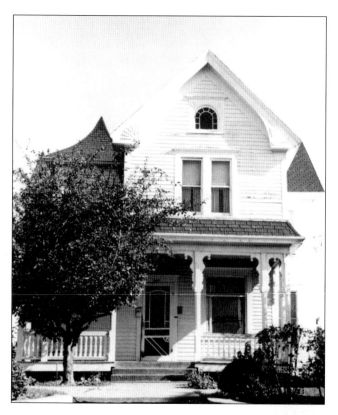

The Strout house on Florence Avenue, now 100 years old, proclaims its vintage in the prominent stained-glass window under the gabled roof. The house is listed on the National Register of Historic Places, as are the West County Museum (P&SR Depot) and Burbank's Experiment Farm cottage.

Mr. and Mrs. George Strout stand proudly in front of the home Mr. Strout built for his family. George Strout and his son A.L. Strout owned the Analy Planing Mill in Sebastopol at the turn of the 20th century. George Strout used his carpentry skills on many homes in Sebastopol, making especially fine staircases. He also produced utilitarian items such as beehives, ladders, and fruit dryer trays for agricultural use.

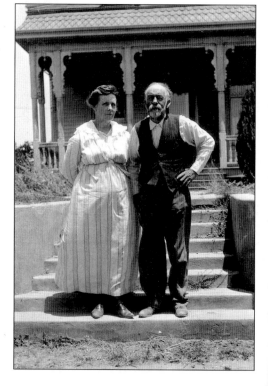

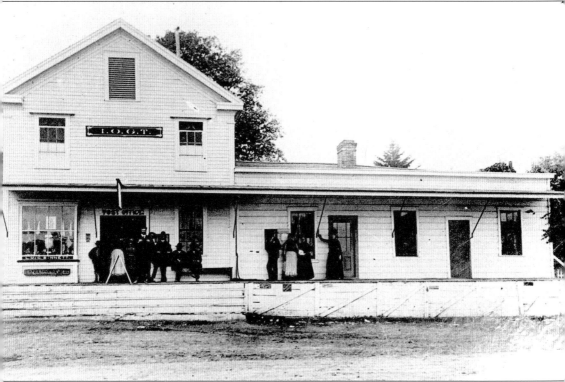

As early as 1897 there was a chapter of the Women's Christian Temperance Union in Sebastopol, and the Independent Order of Good Templars (IOGT), a temperance group for both sexes, was founded in 1879. Joseph Morris, Sebastopol's founder, was a charter member of the IOGT lodge, which provided social activities free of alcohol, along with moral and financial support for inebriates when needed. Note Sebastopol's early post office location. (B)

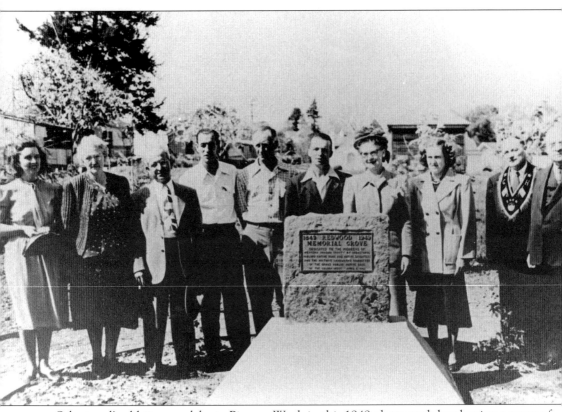

Sebastopol's old timers celebrate Pioneer Week in this 1949 photograph by planting a grove of redwood trees in Ives Park for the Gold Rush centennial. Mrs. Sarah Pitkin, the daughter of early hop growers Amasa and Alpha Bushnell, was listed as the oldest resident. Sarah, having been born here in 1866, spent only two years away from Sebastopol when her father was the lighthouse keeper at Alcatraz. (SCM)

The Pacific Ocean provided a resource for a varied diet during the Depression. Ivan Roberts (left) and Herman Buehn show off the catch of the day and their abalone hunting success in the days when there were no fish and game restrictions. (GDR)

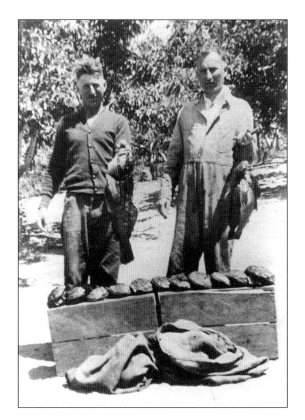

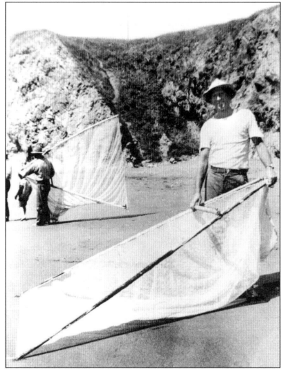

Wind surfing? Not as such, but surf fishing provided lots of exercise diving between waves for Ivan Roberts (foreground) and Cliff Schultz. (As though these gentlemen needed exercise!) Roberts was an apple farmer at Spring Hill, having come to Sonoma County from Oklahoma at age one in 1900. (GDR)

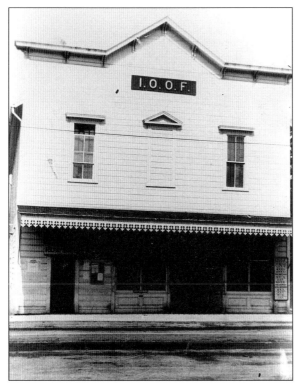

The Independent Order of Odd Fellows, Evergreen Lodge No. 161, began in 1869 with seven charter members. The Masonic Order's Lafayette Lodge No. 126 F&AM organized in 1858 with eleven charter members, including Sebastopol founder J.H.P. Morris. The Masons and the Odd Fellows provided Sebastopol's first cemetery where members and the general public found final resting places. (B)

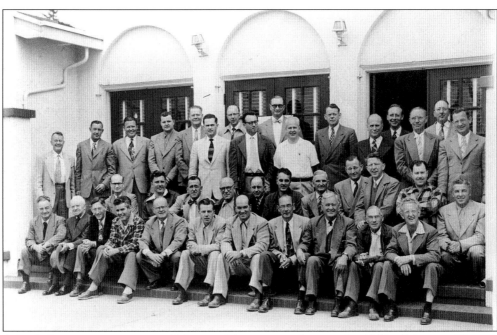

A lively Rotary group meets in Sebastopol for a group photo in the 1950s. Sebastopol Rotary received its charter in 1925, choosing as their first president Horace "Hod" Weeks, who owned the former A.E. Finnell hardware store. Weeks and other Rotarians helped organize the 1915 Apple Show. (GDR)

Nine
GETTING DOWN TO BUSINESS

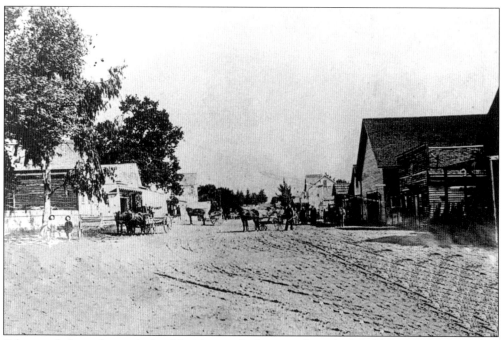

Sebastopol always boasted a healthy climate for business from the humble start when a trading post was set up in 1850 on Joaquín Carrillo's land grant. Typical early businesses as seen in this 1874 photo of Main Street were livery stables, hardware stores, dry goods, hotels, and the ubiquitous saloons. At one time, with the town having about 750 inhabitants, there were 14 saloons operating in the city limits. As the needs of the city and surrounding countryside changed, so did the businesses in the city change to reflect the times.

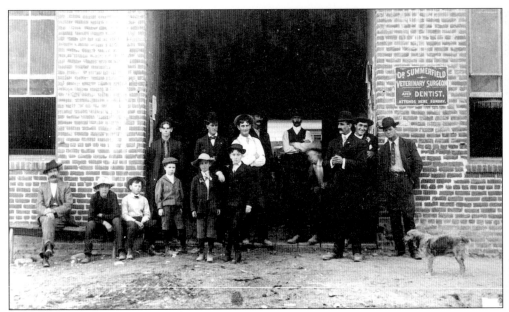

A.I. Sullivan, proprietor of the Golden Rule livery stable on South Main and Burnett Streets, advertised 12 horses, 12 buggies, 2 surreys, and 1 wagonette for hire. Dr. J.J. Summerfield, a well-known Santa Rosa veterinary surgeon, had offices in the livery for his weekly visits. The building was just south of the Analy Hotel on Main Street.

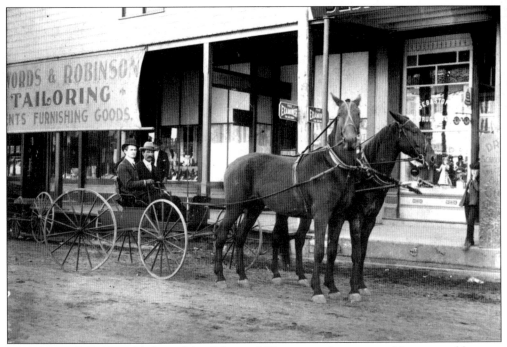

J.P. McDonell (left), publisher of the *Sebastopol Times*, was the owner of four-year-old pacers Queen and Princess, touted as the fastest road team in Sonoma County in 1901. McDonell and Clyde Berry are pictured in front of the Swords and Robinson Tailor Shop on Main Street, which specialized in men's clothing, woolens, cashmere, and fancy silk. (DM)

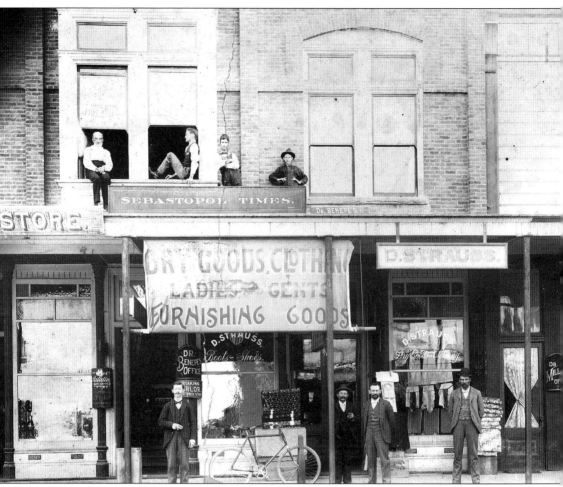

David Strauss' Bargain House is seen in this *c.* 1895 photograph. The store, located near today's Copperfield's, advertised "ladies' hosiery, fine black, the 50¢ quality now 35¢, and men's and boys' pants at $3 a pair." This last deal is credited to a "spot cash buy otherwise we would not be able to sell them less than $4." Strauss moved his business to Petaluma in 1900 and opened a tailor shop with his brother-in-law. Upstairs housed the offices of the *Sebastopol Times*, which had many changes of location and publishers but never suspended publication nor failed to bring news of general interest to subscribers. The custom of the early years was to put advertisements on the front page with important news events beginning on page three. A year's subscription was $1.50 in 1900.

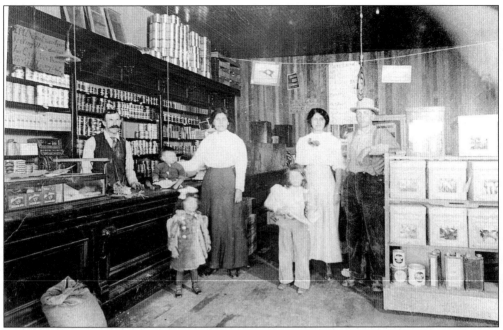

In this photograph we see the interior of the store and fish market of Marc Louis Buvelot, a Swiss immigrant (left) and his wife Margaret Smith Buvelot, posing with their two children. The Buvelots were married in 1909 and worked together in their store. Margaret was the daughter of William Smith, a Bodega Bay Miwok elder. (GB)

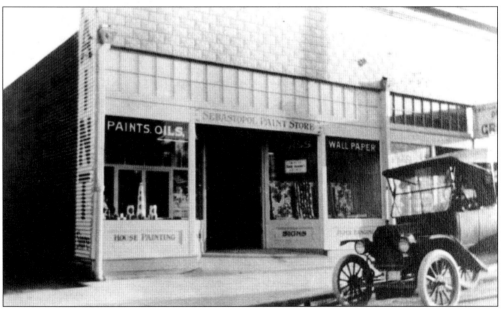

Nauman's Sebastopol Paint store was located on Bodega Avenue next to O'Leary's Funeral Parlor. Joseph Nauman, born in Germany in 1862, came to Sebastopol with his wife, Emma, in 1909 where he opened his paint store. He was a painter himself and contracted to paint buildings, leaving his mark on many of the prominent buildings of the time.

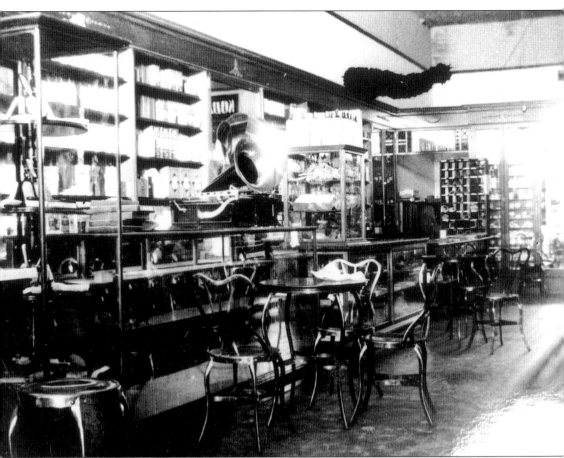

Worth and Company Drug Store had all the usual drugs, stationery, and toilet and fancy articles as well as being the agents for the Sunset Telephone Company. Started in 1900 by Thomas R. Worth, a trained druggist, the store's offerings included Worth's Spring Medicine, the literature for which read in part, "it is pleasant to take and makes rich, red blood. It insures a fair skin and brilliant complexion. It cures constipation. By acting also on the kidneys and liver it aids the process of nutrition and restores the normal functions of the system. Only 75¢ for a pint bottle."

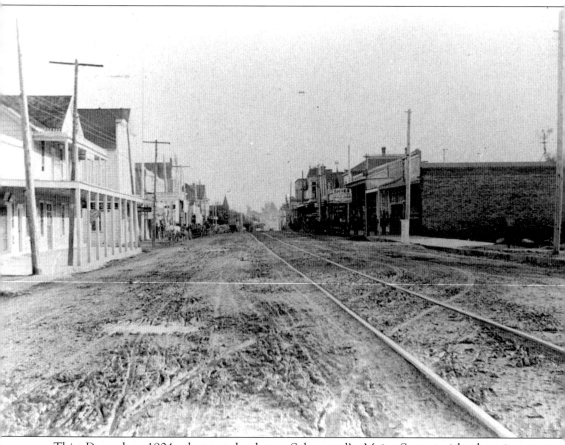

This December 1904 photograph shows Sebastopol's Main Street with the city now incorporated and businesses prospering. The railroad now goes down Main Street with the Petaluma and Santa Rosa Electric Railway. On the left are a grocery store, candy and notions shop, printing shop, dry goods, and millinery, and at the far back is the steeple of the Methodist Episcopal Church, located where today's Methodist Church stands. On the left side of the street are several saloons, general stores, the post office and the United States Hotel, William Dowds, proprietor. The hotel's ad read, "U R Always Welcome."

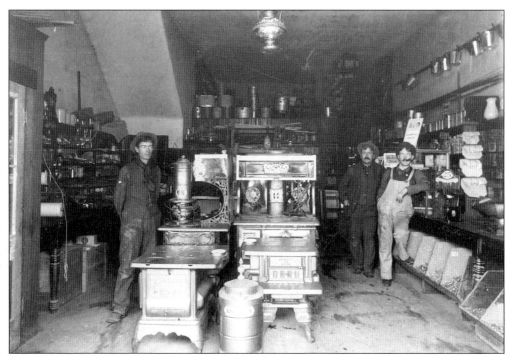

Finnell Hardin Hardware Store was the largest hardware store in western Sonoma County in the early years of the 20th century. They carried stoves, heaters, cutlery, wallpaper, and an extensive stock of agricultural implements. They also maintained a plumbing establishment that was equipped to do everything in the line of plumbing, gas fitting, erecting of windmills, fitting up wells, and all manner of repairs.

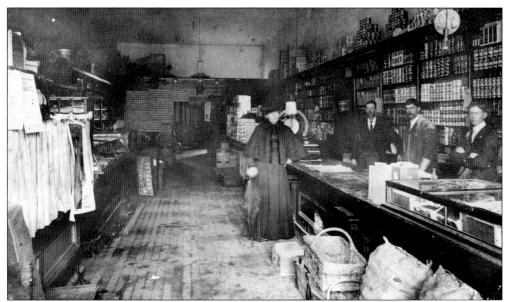

The interior of a grocery store shows cans neatly arranged on shelves on the wall. Clerks would retrieve a customer's order, as the do-it-yourself age had not arrived. Safeway and Flemings, "modern" supermarkets, didn't open in Sebastopol until the late 1920s.

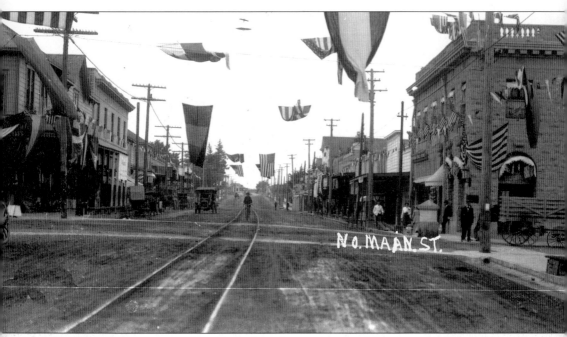

North Main Street is seen here decked out for a patriotic celebration. On the right is the Bank of Sonoma County, built in 1904 at a cost of $30,000 and extensively remodeled in 1914–1915 at an approximate expense of $140,000. It was recognized as one of the strongest rural banking institutions in California. In front of the bank at the corner of Main Street and Bodega Avenue is a fountain erected by the Women's Christian Temperance Union, an active prohibitionist group. The fountain, often knocked over by drunks on Saturday nights, was maintained up to the 1950s by members of the WCTU.

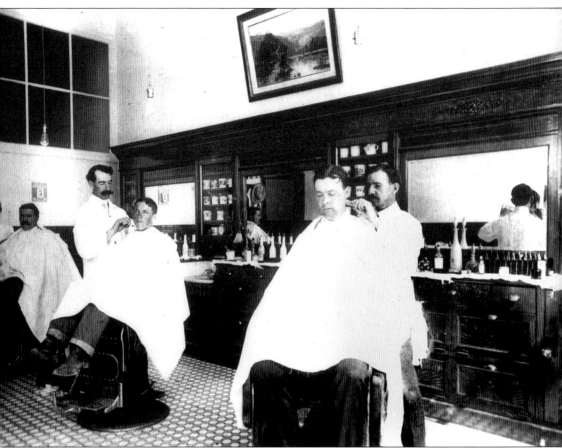

In the fall of 1898, A.S. Phillips and his brother Bert started a barbershop, located in an early pool hall, with an ad that read, "Shave 15¢ and haircut 25¢." They made various business moves and at different times partnered with George Gibson and Clyde Berry. In connection with the shaving parlor there was a well-equipped bathroom offering hot or cold baths. This photo was taken in 1905. In the 1906 earthquake, the quake shook the building down but one of the barber chairs held the roof off the floor.

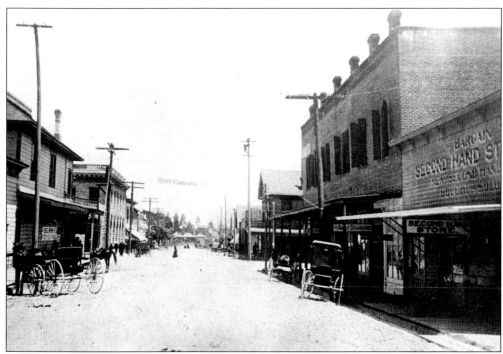

Looking east on Bodega Avenue, the Bank of Sonoma County anchors Main Street on the left. Before paving began in 1910, Main Street was either a mud hole or it was very dusty. The city solved the dust problem by having horse-drawn wagons bring tanks of water from a well at the corner of Mill Station Road and creak slowly down the street hosing down the dust. Horse droppings are evident on the unpaved roads.

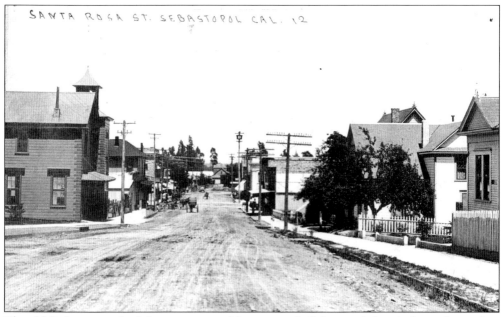

The old firehouse on the left was converted from an early Sebastopol church. It was located up Bodega Avenue near the city hall and the Carnegie Library.

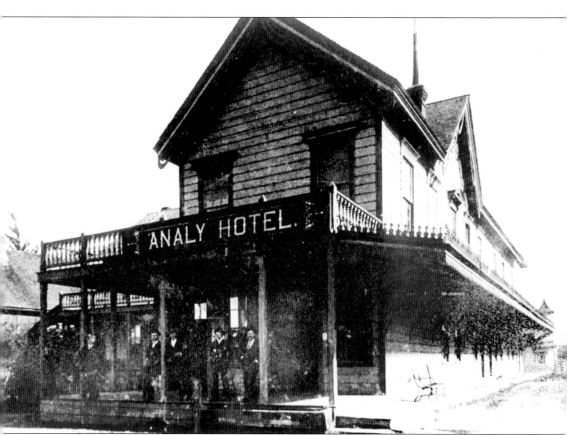

The Analy Hotel had a long career, beginning as a home built by landowner Joaquín Carrillo of the Rancho Llano de Santa Rosa. Carrillo called the hotel Analy after the township name. The hotel was moved in 1890 to what is now the First National Bank site on Main Street and Bodega Avenue and was owned by Mr. J.B. Loser. Around 1910 the building was moved a second time to Main and Burnett Streets. The building was razed eventually, but a portion of the hotel survived and was purchased in 1942 by Mrs. Anita Garloff who had planned to modernize and make improvements. (SCM)

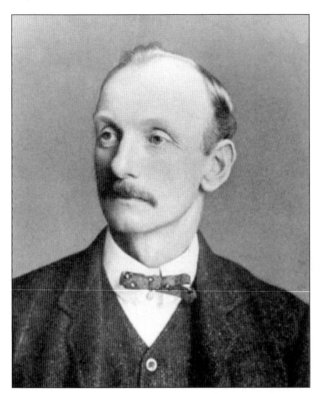

A Sebastopol native and son of early settler Joseph H.P. Morris, Harry (H.B.) Morris was the head of the first board of trustees of the newly incorporated city of Sebastopol. He bore the title of "president" instead of "mayor." Other members of the board were A.H. Laton, William Dowd, C.T. Snow, and Charles Burroughs. E.F. O'Leary was named marshal. (SCL)

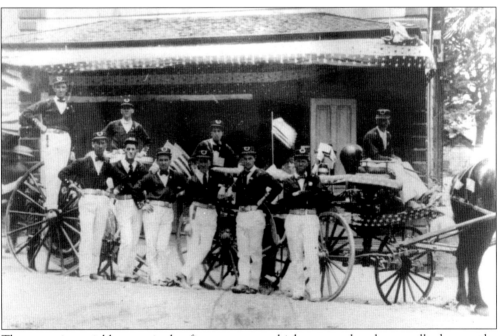

The new city quickly organized a fire company, which proposed to have wells dug on the principal streets and to purchase a hand engine. In this 1909 photo the volunteer firemen, from left to right, are as follows: (front row) Pete (Angelo) Pellini, Joe Borba, Frank Donnelly, Vivian Berry, and driver E.G. Sharp; (back row) Frank Lockwood and Herman Nauman. (SFD)

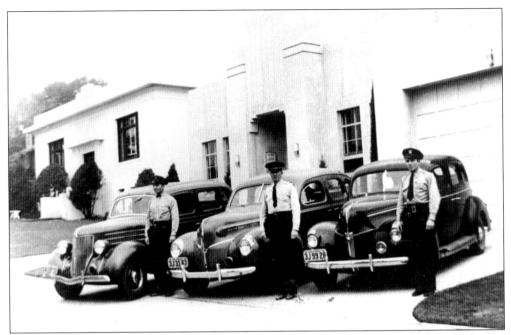

From the early days when Marshal O'Leary's biggest expense was $14 for the burial of seven dogs, the police grew to a force of three in 1941, here pictured in front of city hall. Officers had to use their own vehicles and mount a red light on the front. Pictured, from left to right, are Jim Morris, Chief Ed Foster, and Bill Lawrence. (SPD)

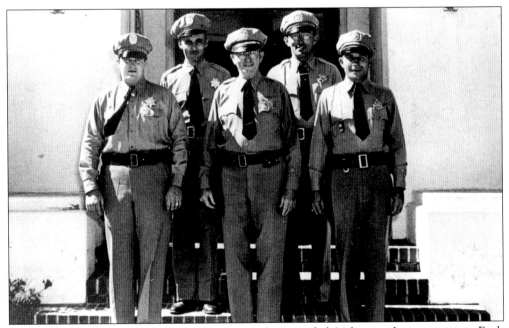

By 1946 the police team numbered five men, who provided 24-hour police protection. Each officer owned a well-equipped automobile and patrolled not only the business area but the residential district as well. Ed Foster had been police chief since 1927. Pictured from left to right, are Don Goss, Ed Major, Chief Ed Foster, Buck Rose, and Captain Bill Lawrence. (SPD)

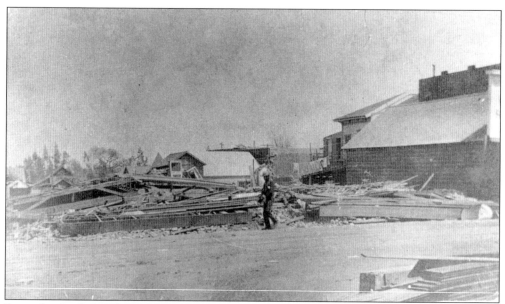

From the *Analy Standard*: "The earthquake of April 18, 1906 struck Sebastopol at about 5:15 a.m. and in less than a minute's time every brick building in town was either a total wreck or seriously damaged, but most luckily not a single person was hurt. The Barnes Block in which were located Ronsheimer's Store, Berry and Phillips barber shop and Borba's cigar stand, collapsed and is a complete loss."

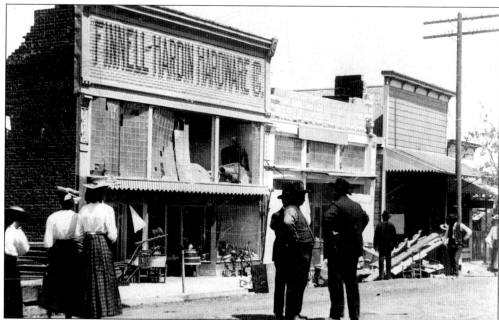

More earthquake damage is shown here. The *Analy Standard*'s April 21, 1906 edition said, "Finnell and Hardin's new brick store is seriously damaged. Nearly all the chimneys in town were broken off and many dwelling houses were shaken from their foundations . . . windmills and tanks were shaken down and it is stated that not a monument was left standing in either of the Sebastopol cemeteries."

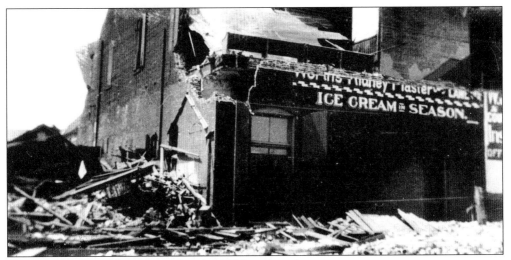

Worth's Drug store shown just after the 1906 earthquake.

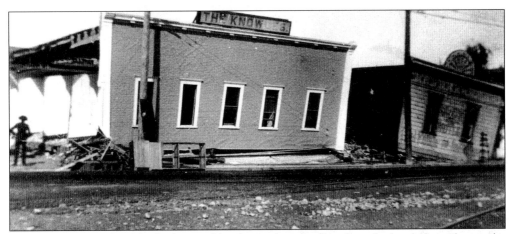

The Knowles Hotel was badly damaged by the earthquake. People rushed to help and soon the debris was cleared and a more modern town prospered as never before.

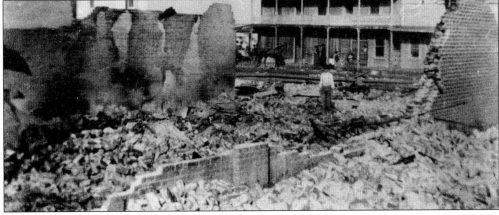

The destroyed Barnes Block, seen here with the Analy Hotel across Main Street in April 1906.

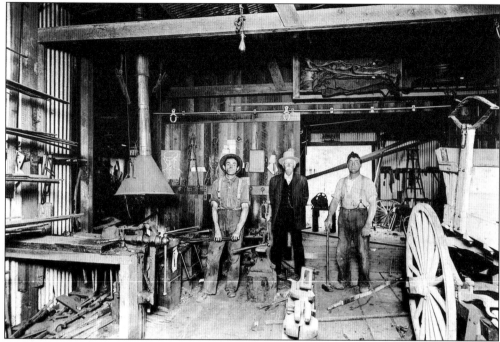

In this photograph we see the interior of Berry's Livery Stable, located on Main and McKinley. Starting in 1872, Samuel B. Berry ran the Fashion Livery Stable. The enterprise would haul freight to and from the depot and move household goods; it was billed the "leading stable in Sebastopol." In 1903 Berry traded the stable for a farm in Green Valley, and Will McChristian took over the stable business.

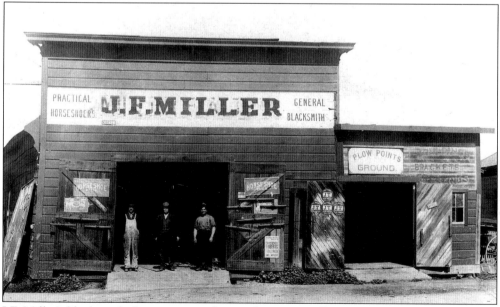

J.F. Miller's blacksmith shop was one of many that eventually succumbed to the automobile, although the need for a blacksmith repairing farm tools and doing general iron work continued into the 1930s.

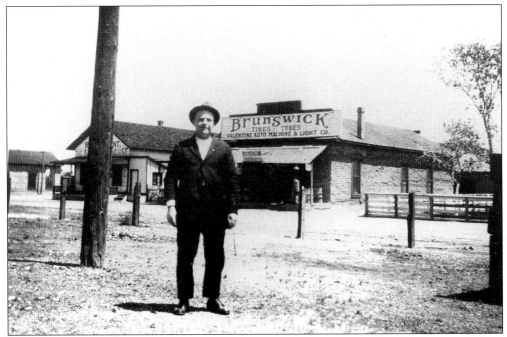

Employees at the Valentine Auto Machine and Light Company demonstrate the change from a horse-drawn culture to an automobile culture. Instead of horseshoes, now the demand is for tires for the car. (SCM)

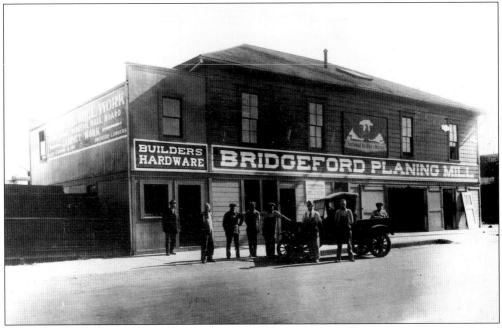

The Bridgeford Planing Mill was located near the present C.W. Ford on Sebastopol Avenue. The photo is from the 1920s and features a Model T in front of the business. There were several planing mills over the years that produced wooden products such as windows, doors, moldings, and fruit trays for the large canning and drying businesses in town.

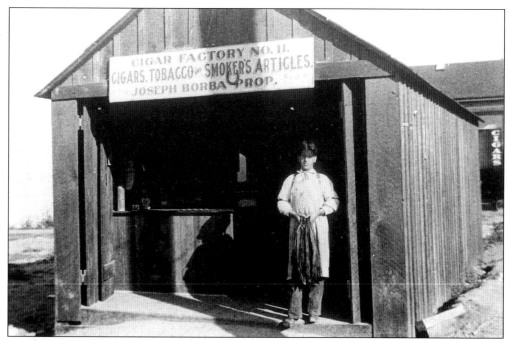

Joseph Borba, pictured above, moved to Sebastopol with his parents in 1892, and he made cigars and ran a cigar shop for many years. Tobacco was grown in many places in Sonoma County, where the rich loam was considered ideal for tobacco by David Hetzel of Guerneville. C.W. Reynolds of Santa Rosa grew tobacco in the adobe soil and received an impressive output of a half a pound of cured leaf per plant. (SCL)

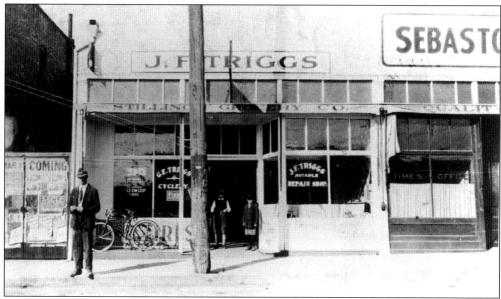

J.F. Triggs (left) is shown in front of his bicycle repair shop, c. 1921. His newspaper ad stated that he "repairs bicycles, locks, guns, etc, scissors ground, saws filed." His son Delbert worked with him as the business became Triggs Auto Parts and Machine Shop. The business was in the family until 1964 at various locations along South Main Street. (GDR)

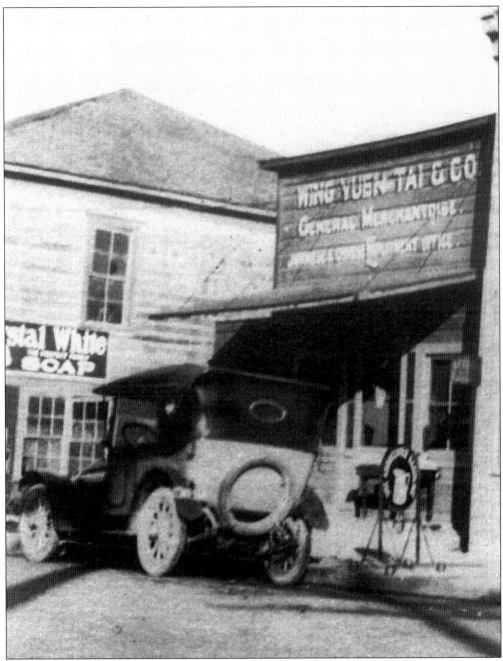

Wing Yuen Tai and Company specialized in "Men and Ladies' Furnishings, Jap and Chinese Silk Goods, groceries, fancy slipper, China lilies and bowl, Prices Reasonable" according to its 1917 newspaper ad. Sebastopol had several "Chinatowns" in its history; one was located on North Main Street in the 1880s and 1890s and was removed in about 1892. There was a big fire in "new Chinatown" in 1902, with 15 buildings destroyed, including the Joss House. The newspaper bemoaned the woeful lack of fire-fighting facilities. Wing Yuen Tai's business was near South China Avenue, where the "new Chinatown" was located from 1900 until the 1940s. C.W. Ford is located there today.

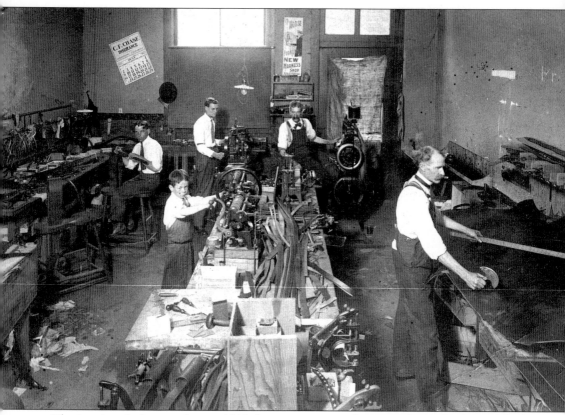

The interior of a harness shop in 1912 shows a very young boy at work. As the demand for horse implements diminished, harness shops disappeared from the Sebastopol business scene. Palmer's harness shop included Andrew Christensen who was a shoemaker at the turn of the 20th century.

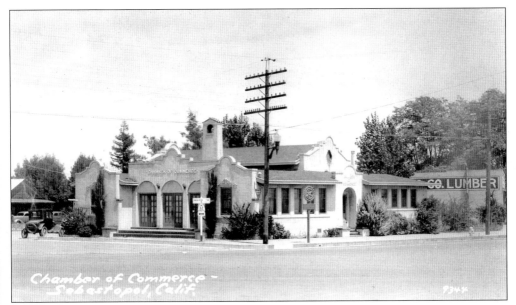

The chamber of commerce, organized in 1921, contributed immeasurably to the growth of the city by conducting beautification projects, erecting street signs, establishing the first auto park, and organizing the California Gravenstein Apple Growers. The chamber's offices were built in 1923 at the corner of Sebastopol and Petaluma Avenues.

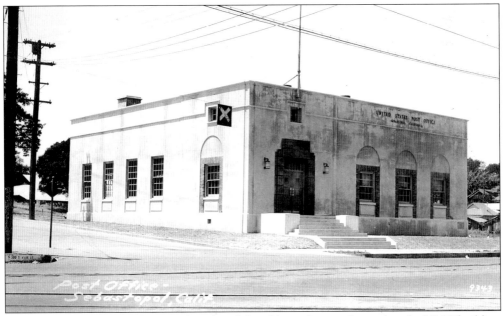

The "new" post office, built in 1935, replaced the old site that was located in the IOOF building for many years. How bare it looks without that magnificent magnolia tree!

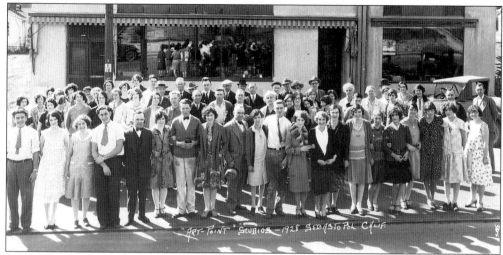

Art Point Studios, located at 340 North Main Street, was founded by Charles R. Myers in 1917. The business specialized in engraving and thermography to produce social stationery, wedding invitations, business cards, and items for advertising or personalized use such as book matches. Myers leased his building from Jerome Hobson, a prominent hop grower, who constructed the structure to Myers's specifications.

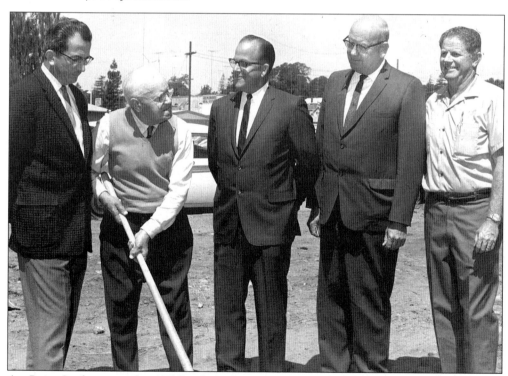

Art Point Studios moved to 275 Petaluma Avenue in 1966, after the business had outgrown its former quarters on Main Street and a large and modern facility was planned. Pictured for the ground breaking, from left to right, are Bill Goss, production manager; 87-year-old Charles R. Myers, founder; John Williams, owner; Mayor F.G. McKinley; and Ben Oretsky of Wright and Oretsky, contractors.

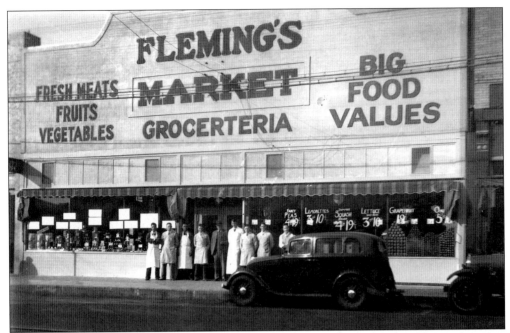

Flemings Market, seen here in 1930, was established in 1929 by Robert Fleming at 108 North Main Street. According to its ad it carried the largest line of groceries in the county. A complete stock of nationally advertised brands of groceries, meat, fruit, and vegetables were maintained. It was locally owned and operated by Sebastopol citizens.

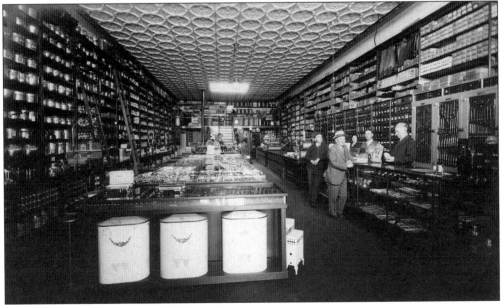

Weeks Hardware at 6948 Sebastopol Avenue, which carried one of the largest stocks of hardware in this part of California, was purchased from A.E. Finnell in 1909. Mr. Weeks was a well-known businessman and civic leader for many years. Pictured, from left to right, are Louie Coveghino, Jack Starkey, Sarah Sollars, Jim Cruse, and H.M. "Hod" Weeds, owner. The man in the rear of the store is Henry Singmaster.

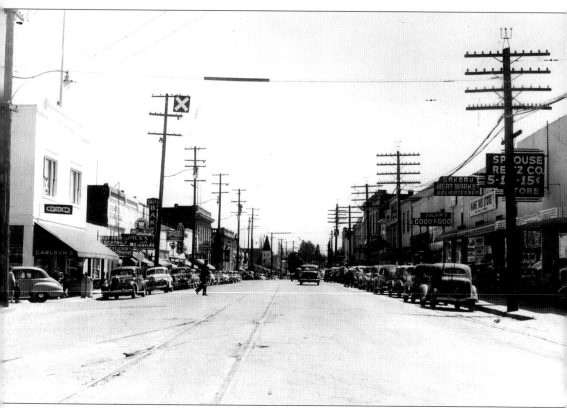

On the left in this 1940s scene of Main Street can be seen a staple of Sebastopol: the saloon. In 1900 Sebastopol supported 14 saloons, with a population of just 750. When challenged about the relatively low retail license fee in 1903, the town's new board of trustees stated that if Sebastopol's saloons were closed by a high license, others would open just beyond the corporate limits where they would be entirely out of the jurisdiction of the trustees. That view only prevailed until 1910 when a fee of $1,000 was levied and the result was a dramatic drop in the number of saloons to five. Wilton Street used to be known as "Jag Alley" because the ladies of town didn't want their husbands driving home down Main Street when they had a "jag" on.

The First National Bank of Sebastopol was moved to this building in 1910, in the place of the old Analy Hotel at the corner of Main and Bodega Avenues. Organized in 1892, it was fundamental in the early growth of Sebastopol. It was acquired by the Bank of America in 1933. Although changing owners many times over the years, the building remains and today houses a restaurant and apparel shop.

Old Palm Drive hospital, the solarium of which is pictured above, was not the first hospital in Sebastopol. That honor goes to Mrs. Amelia Mihan, R.N., who owned the Hillside Hospital, pictured below, on North Main Street from 1934 to 1942. In 1941 Al Helwig built the Old Palm Drive Hospital and greatly improved medical facilities in the city with this modern and spacious hospital.

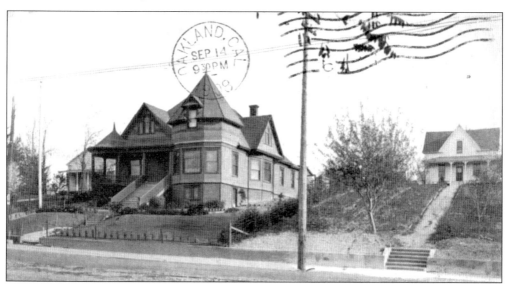

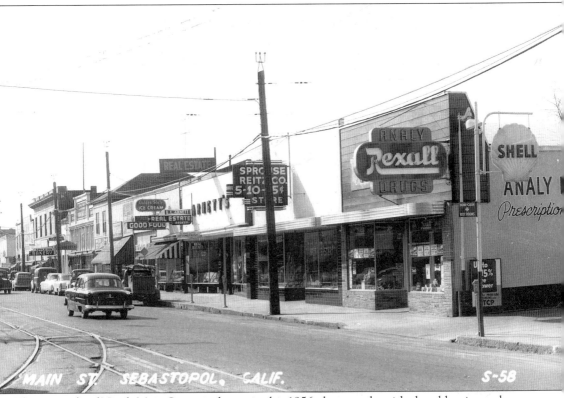

The west side of North Main Street is shown in this 1956 photograph, with the old train tracks still visible. Shell was to become Miller's gasoline station and the Rexall will be transformed into the new Basso Furniture building.

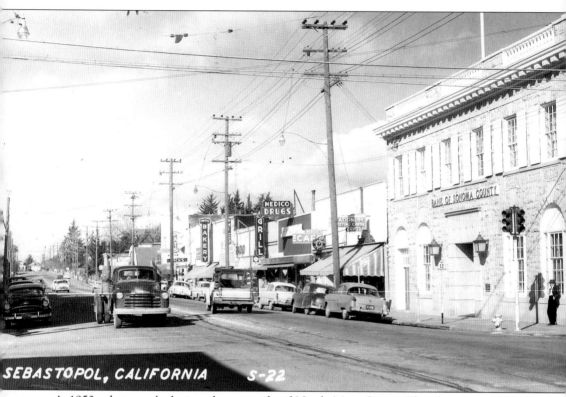

A 1950s photograph depicts the east side of North Main Street. The charming old Bank of Sonoma County, a landmark since 1904, now no longer occupies the corner at the center of town. The saga of Sebastopol business is one of constant change. Over the years the buildings have come and gone as have many establishments. It will be interesting to see what the future will bring.